IMAGES
of America

LOMBARD COLLEGE

IMAGES
of America

LOMBARD COLLEGE

Shaun Dauksas

ARCADIA
PUBLISHING

Published by Arcadia Publishing
Charleston, South Carolina

Printed in the United States of America

Library of Congress Control Number: 2023933964

For all general information, please contact Arcadia Publishing:
Telephone 843-853-2070
Fax 843-853-0044
E-mail sales@arcadiapublishing.com

Visit us on the Internet at www.arcadiapublishing.com

*I dedicate this book to my grandfather, who fostered
my love of reading and lifelong learning.*

CONTENTS

ACKNOWLEDGMENTS

I would like to thank Knox College in Galesburg, Illinois, for allowing access to their archives and maintaining the records of Lombard College. Special thanks to Knox College archivists Joseph Taylor and Maryjo McAndrew. Another thank-you to the Galesburg Public Library and their archivist Emily DuGranrut for their assistance. Additional photographs were supplied by the University of Illinois, Oregon State University, Stanford University, and Harvard Divinity School.

INTRODUCTION

Galesburg, a small city in northwestern Illinois, once had the nickname College City when it was home to two four-year colleges. The first was Knox College, established in 1837 by Presbyterians and Congregationalists. Fourteen years later, there was new competition in town that would challenge the idea of sectarian education.

In 1850, a group of like-minded Universalist church members met in Greenbush, Illinois, at the home of Amos Pierce. The meeting was led by a charismatic Universalist preacher named Rev. Charles West. He urged the creation of a new progressive academy; although it would be church-based, there would be no interference from the church, and the academy would offer a completely nonsectarian education. West described the school as a "seminary of learning." In addition, the school would be completely coeducational, allowing women to have the same opportunities as men. The group accepted Reverend West's ambitious plan and gave him approval to present at the Spoon River Association of Universalists meeting on May 19, 1850.

Reverend West's proposal was approved, and the funds to create the academy were raised by the fall of 1850. After the funds had been raised, a charter was granted by the State of Illinois for the newly formed academy, which was named the Illinois Liberal Institute on February 15, 1851. The charter specifically stated that no property over $20,000 could be held at one time, keeping the institution bound to its original purpose as an academy offering the equivalent of a modern high-school education.

A two-story brick school building was constructed at the northwest corner of South Seminary and East Tompkins Streets in Galesburg. Classes were first held in the new building in the fall of 1852, and Rev. Paul Raymond Kendall was selected as the first president. While Kendall was happy with the early success of the school, he began dreaming of something more—his ambition was to eventually turn the academy into a college.

There was little enthusiasm from the trustees to begin working toward the creation of a college, but through Reverend Kendall's persistence, the trustees eventually amended the charter to allow for the raising of $50,000 in 1853. There is belief that the trustees set the dollar amount that high because they had hoped it would be an impossible task for Kendall. Kendall took a vital step to help his cause by hiring professor Dr. John Van Ness Standish in 1854. Standish was no stranger to Kendall, as they were former Norwich University classmates. Kendall knew he could count on Standish to support his vision. While this would not be enough to green-light the college, an unforeseen circumstance came to Kendall's aid.

In April 1855, a fire broke out, destroying the Illinois Liberal Institute school building. Reverend Kendall rushed back from his fundraising endeavors to find Dr. Standish had arranged temporary quarters to keep the school running. Largely due to the sympathy inspired by the fire, Kendall was able to successfully acquire the $60,000 needed to rebuild and reopen the school as a college. A large portion of the funds came from a $20,000 donation by local businessman Benjamin Lombard. The new college building was located on the southeastern side of Galesburg, and the first classes

were held there in the fall of 1856. An amendment was passed in February 1857 renaming the school Lombard University in tribute to its largest donor.

Under the leadership of college president Dr. Charles Ellwood Nash, the 1890s marked a time of growth as both a gymnasium and female dormitory were added, creating a more traditional college campus. In 1900, Lombard University changed its name to Lombard College, with the new name reflecting a focus on undergraduate education. References in this book to Lombard as both a university (1857–1899) and a college (1900–1930) align with the time in which events took place.

In contrast to the growth of Lombard College, the school's first major financial concerns became public in 1905 under the presidency of Dr. Lewis Beals Fisher. Rumors began to circulate about a possible merger with Bradley Polytechnic Institute in Peoria, Illinois. Trustees explored other possible destinations for the college in towns ranging from Quincy to Springfield. Many saw the need for Lombard to get away from the crosstown competition of Knox College. Nothing came of the miniature crisis. One thing was for certain, though Lombard needed to find new ways to raise money.

Rumors of Lombard College's demise resurfaced in 1912. There was growing pressure to consolidate with Knox College. Lombard College president Dr. Fisher publicly laid out all possible outcomes in a bulletin to students and alumni. Pressured by the increased competition of Knox College and the growth of state colleges, Fisher candidly discussed the long-term viability of surviving as an institution in Galesburg. Once again, Lombard chose to remain independent, and the problems were pushed aside. Through the adversity, Lombard started building a brand-new gymnasium in 1913, keeping Lombard up to date with other colleges of its time.

Lombard College appeared reinvigorated in the 1920s under the guidance of president Dr. Joseph Tilden, who was a passionate fundraiser. President Tilden successfully raised enough money to turn the original gymnasium into a state-of-the-art science hall. A large push for athletics also came from Tilden. At this time, Lombard began grabbing national headlines in football by setting records and winning several conference titles. The renaissance at the college was not long-lived, and Dr. Tilden passed away suddenly in 1928. Lombard College lost a major friend, ally, and fundraiser with his passing.

On the surface, there was much to celebrate, but the competition from other schools in the state did not disappear. One last attempt to find proper financial backing came in March 1928. The Unitarian Church gave Lombard College $250,000 to run the school jointly with the Universalist Church. Unfortunately, the stock market crashed on October 28, 1929, quickly dampening any joy from the newfound partnership. The onset of the Great Depression put Lombard College on life support.

In April 1930, Lombard College president George Davis contacted Knox College about merging the two colleges. Talks went on for over a month, but a merger made no financial sense for Knox. Lombard had a large amount of debt with little value to bring to any potential union. Ultimately, the merger collapsed, but Knox offered all Lombard students the ability to transfer credits and keep the tuition rates they paid at Lombard. All records transferred to Knox effective July 1, 1930.

Lombard College's last commencement was held on June 3, 1930. During the commencement speeches, there was no mention of the demise of the college. One somber tribute that day occurred when the ceremony commenced, and the Lombard College bell rang 79 times in tribute to the 79 years the college had been in existence. The following chapters detail the people, traditions, and places that were the heart of Lombard College.

One

CAMPUS AND HISTORY

Lombard College's 13-acre campus was on Galesburg's southeast side bounded by East Knox Street, Lombard Street, Locust Street, and Maiden Lane. The land was purchased from Lorentus Conger, one of the school's first trustees. Unlike Knox College's downtown location, Lombard's campus was nestled in the middle of a growing neighborhood that separated it from downtown Galesburg. Often, the campus and the neighborhood blended, as Lombard used nearby houses for boarding, fraternities, sororities, and faculty housing. While there were limitations that came with being isolated from downtown, the college used its location as a selling point by advertising its secluded distance as a way to prevent any distractions or unruly temptations for students.

After a fire burned down the original school building, it was time to rebuild and design the layout of the campus. Old Main, the massive three-floor, brick, castle-like structure, was plotted on the northern part of campus. As Lombard College expanded, the main buildings on campus included Lombard Hall, Tompkins Science Hall, and the Lombard Gymnasium. Each was connected by winding paths carefully decorated with various plant life, giving the campus its well-known serene beauty. Over the years, students developed their own personal connections to parts of campus, whether it be memories of getting water from the old pump, hoisting class colors from the flagpole, or even ringing the bell after a football victory. All these elements gave the campus its own unique personality and vibrant story.

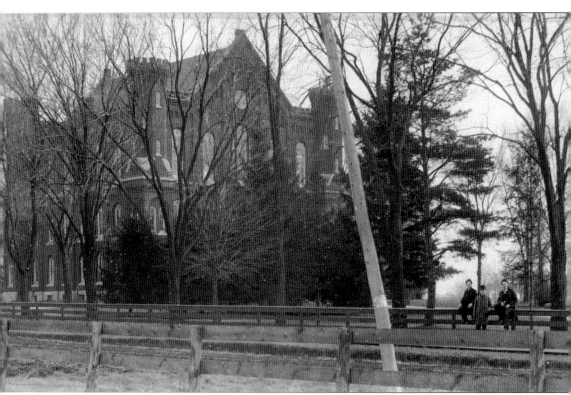

Old Main's first floor was completed in the fall of 1856, allowing for the first classes to be held under a temporary roof. By the following fall, the next two floors had been built, but once again, a temporary roof had to be used. It was not until the fall of 1858 that Old Main had its permanent roof. The delays were caused by the original contractor committing to too low of a rate, financially ruining himself in the process. Like the exterior, the interior also was completed in pieces. During the first years of use, there were no banisters on the stairwells and no baseboards in the classrooms, and the chapel was unfinished. The first winters were extremely challenging for students and faculty. Individual stoves in each room were the only source of heat. Pictured are three Lombard University students sitting on fences that lined East Knox Street, with Old Main in the background. (Special Collections and Archives, Knox College Library.)

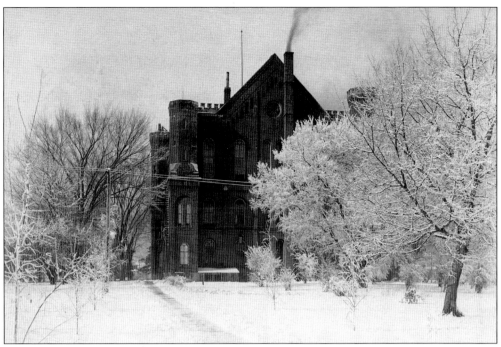

Old Main, at 66 by 80 feet, contained the administrative offices, 16 classrooms, the library, and the chapel. Originally, the founders envisioned having additional buildings similar to Old Main connected by corridors. The corridors would have been attached to Old Main through its south entrance. None of the expansion plans came to fruition, and Old Main remained the only building on campus until 1896. These photographs give different views of Old Main—above is the eastern side, and below is the south entrance. (Both, Special Collections and Archives, Knox College Library.)

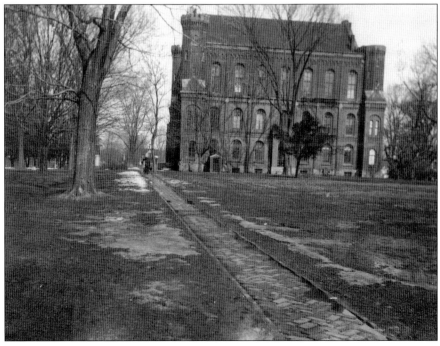

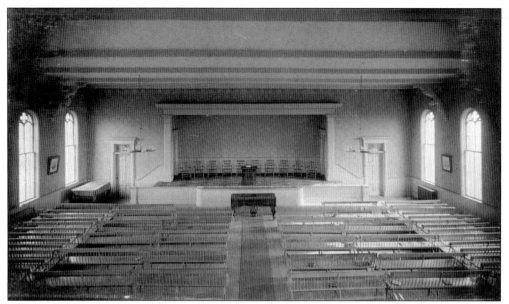

In the early days of Lombard College, students were required to attend chapel each day. However, the college shifted more toward its progressive Universalist leanings in the 1900s, giving students the choice to find a church in town that matched their beliefs rather than attend on-campus services. Old Main's chapel in the 1890s (pictured) was modestly decorated for its primary use as a church. (Galesburg Public Library Archives.)

The chapel saw several changes over the years; in the 1870s, the balcony was converted into a dissecting room for medical classes, but it returned to seating in 1924. Another addition was a portrait of Benjamin Lombard (pictured) that overlooked the chapel. Guest speakers were frequent in the 1920s, including Alaskan explorer Edgar Raine, poet Carl Sandburg, and pianist Glen Dillard Gunn. (Special Collections and Archives, Knox College Library.)

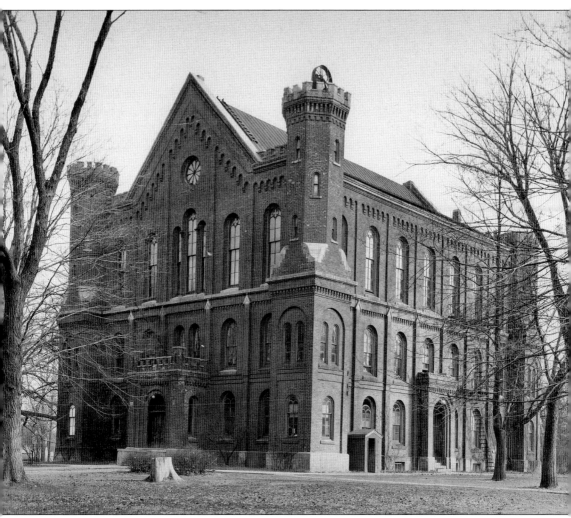

Old Main had several unique features that added to campus lore. The tower in the foreground housed the college bell. While attending college here, poet Carl Sandburg had the honor of working as the bell ringer to indicate time between classes. Sandburg claimed the tower was filled with discarded books that the college did not have room to house. Next to the bell tower, a ladder is seen on the roof. The ladder led to a small hatch that allowed for roof access. On numerous occasions, students climbed through this hatch to hang their class colors from Old Main. The doors on the right side of Old Main earned the nickname the "old spoon holder" for their resemblance to a spoon holder. This hidden doorway became a meeting spot for couples. (Galesburg Public Library Archives.)

One of the biggest myths on campus revolved around Old Main's "unfinished tower." The story told by students was that a young woman's lover left her and never returned. She was heartbroken and threw herself from the unfinished tower. As a result, the construction workers refused to complete it. (Special Collections and Archives, Knox College Library.)

While the students enjoyed spreading the "unfinished tower" myth, the real story is more practical. The southeast tower once had a belfry that held the college bell. Eventually, the belfry became decayed and was never replaced. The bell was moved to the southwest tower for most of the school's history. This photograph offers a rare glimpse of the belfry. (Galesburg Public Library Archives.)

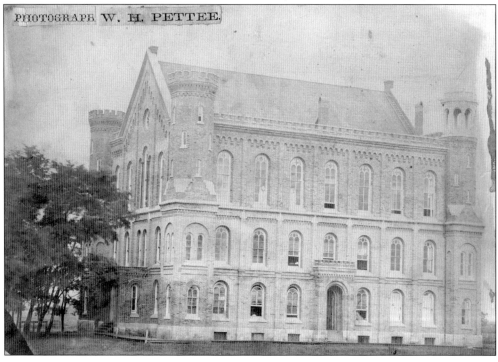

PHOTOGRAPH W. H. PETTEE.

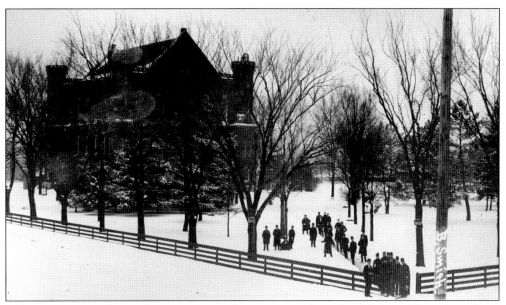

Old Main is pictured near the intersection of East Knox and Lombard Streets. The path students are walking became known to them as the "diagonal walk" for its direction toward Old Main. This path was important as it led directly to the streetcar stop. (Galesburg Public Library Archives.)

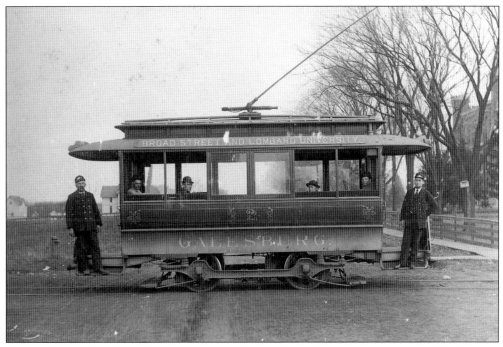

A streetcar arrives at Lombard University, with Old Main at right. Originally, horse-powered streetcars of the College City Railway Company took students to and from downtown Galesburg. By 1892, the Galesburg Electric Motor and Power Company had bought out the old horse line. Lombard College advertised that a streetcar ride from downtown took only seven minutes. (Rare Book & Manuscript Library, University of Illinois at Urbana-Champaign.)

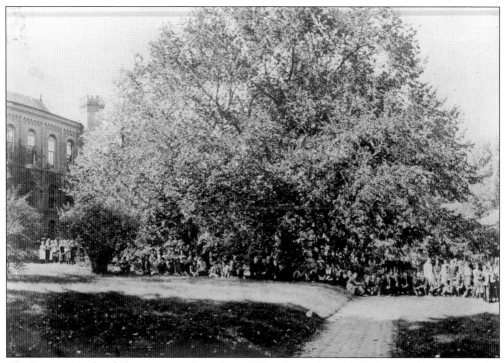

The famous Lombard elm tree was planted in 1868 to honor Lombard alumni who served in the Civil War. At their longest, the tree's branches were estimated to reach 140 feet. The elm was to the north of Old Main's front entrance. These students are posing for a photograph in front of the Lombard elm around 1920. (Galesburg Public Library Archives.)

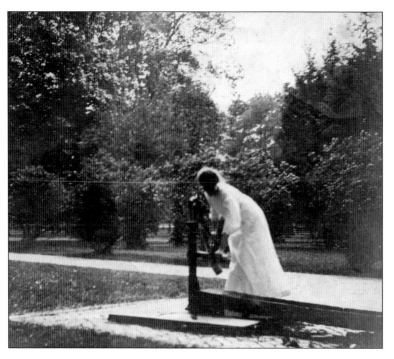

The water pump, affectionately called the old pump by students, was near the front entrance of Old Main close to the Lombard elm. It is reminiscent of a time when water was not easily available, and students had to pump their own. (Special Collections and Archives, Knox College Library.)

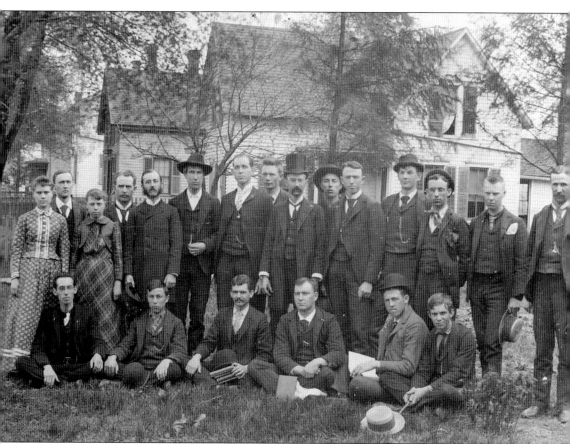

One of the earliest challenges that faced Lombard University was a shortage of student housing. A proper dormitory would cost tens of thousands of dollars, which the school did not have. Students were required to find accommodations in nearby houses, and many opportunistic residents opened their doors. In the university's early years, fully furnished boarding cost students about $4 per week. Another option was self-boarding, costing $2 a week, which meant the student brought their own amenities and only rented the room. The students who lived close to Galesburg were encouraged to self-board, saving the furnished rooms for those who lived far away. The average cost of boarding for a student was an estimated $111 for the school year. Members of the Leech House Boarding Club are pictured in 1890. (Special Collections and Archives, Knox College Library.)

A push for a female dormitory started as far back as 1869. After years of debating the issue, in 1881, the Pine Street Boarding Hall opened one block west of campus. The hall, which was previously a house, had a wing added to give it a total of 22 rooms. Lombard University students are shown standing outside the Pine Street Boarding Hall in 1890. (Galesburg Public Library Archives.)

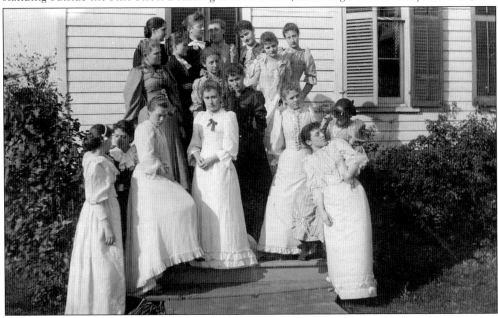

The Pine Street Boarding Hall was initially furnished with discarded or used furniture from the neighborhood. Women had the option of paying for a partially furnished room, which included a mattress, chair, table, and mirror, or a fully furnished room, advertised as the "Minneapolis Room." Here, residents of Pine Street Boarding Hall proudly pose in front of their home for the 1893 school year. (Special Collections and Archives, Knox College Library.)

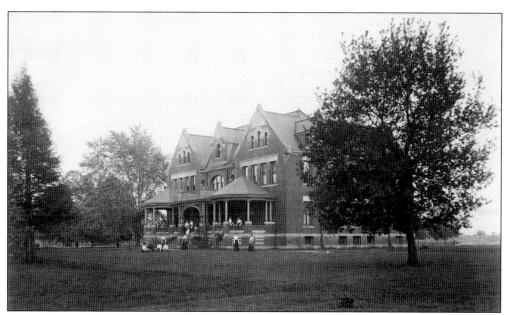

By the 1890s, boardinghouses were becoming outdated in the eyes of alumni and students. Calls began for a proper on-campus female dormitory. Female students needed a safe and modern place to live during the school year, while men boarded or lived in fraternity houses. As a result, Lombard Hall (pictured above) was built in 1896 and opened for students that fall. Lombard University women were required to live in Lombard Hall unless given permission from the college president. The women within the hall practiced their own form of self-government, deciding study times, mealtimes, and punishment for rule-breakers, and electing their own officers. When it opened, the hall could house 40 students. Below, students sit on the steps of Lombard Hall. (Both, Special Collections and Archives, Knox College Library.)

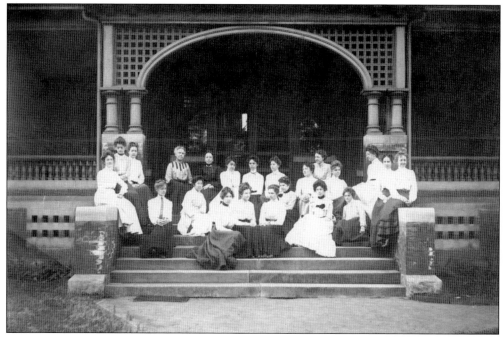

This is the winding path from Old Main that leads to Lombard Hall. Even though the on-campus dormitory was more secure, it was not immune from pranks. One night, several Lombard College football players, covered in bedsheets, snuck through a window in Lombard Hall and began running around. Three of the players were suspended for their nightshirt parade. (Special Collections and Archives, Knox College Library.)

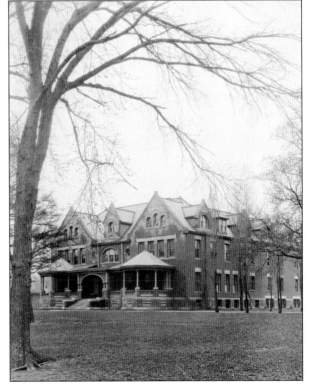

In 1913, a three-story, 40-foot extension was built on the west wing of Lombard Hall, which is visible on the right, adding 14 extra rooms. The first floor of the hall contained the lobby, parlor, sitting room, office, bedrooms, kitchen, and infirmary. The second floor had 22 bedrooms; due to the shape of the roof, the third floor was limited to 9. (Galesburg Public Library Archives.)

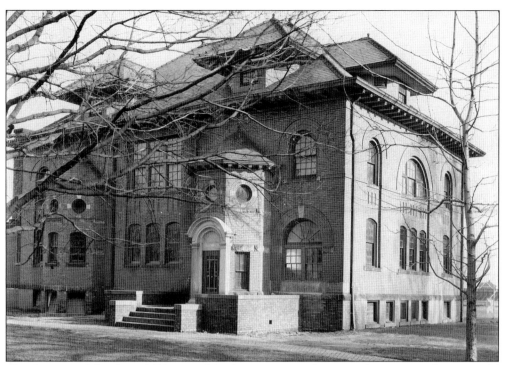

The alumni and the class of 1897 raised funds to construct the original gymnasium between Old Main and Lombard Hall. To the left of the stage, a bronze tablet was erected to commemorate the class of 1897 for their efforts; it is visible below. Legendary University of Chicago football coach Amos Alonzo Stagg dedicated the gymnasium in September 1897. Upon opening, the college finally had a venue for physical education classes and sporting events. The gymnasium had a stage, an upper seating gallery, and a locker room in the basement. Outside athletics, the gym hosted a variety of activities and dances. In 1899, a banquet was held in honor of Dr. Isaac Augustus Parker's 40 years at Lombard, and the event concluded with the college gifting the professor a hand-carved cane. (Both, Special Collections and Archives, Knox College Library.)

By 1913, the gymnasium had become outdated, and it was remodeled into Alumni Hall. The hall had classrooms for public speaking and was designed for professor Binney Gunnison, head of the newly formed Department of Expression. Partitions could be pulled from the wall separating the small rooms from the rest of the building. The slots for the movable partitions are visible in this photograph. (Special Collections and Archives, Knox College Library.)

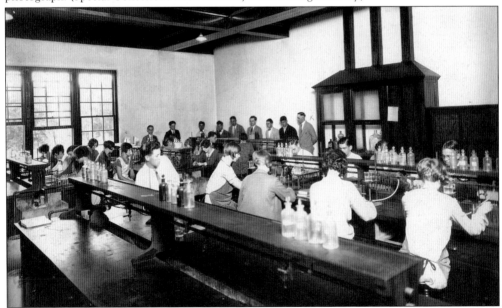

Alumni Hall was remodeled again in 1922 to become Tompkins Science Hall. A $50,000 donation by two former alumni, Ethel Tompkins Clayberg and Nellie Tompkins Ross, made the transformation possible. After the renovation, the building had a lecture hall, laboratories, and departmental offices. In 1924, Lombard began broadcasting WRAM—a student-led, licensed radio station—from the hall. (Special Collections and Archives, Knox College Library.)

The president's mansion was on the northeast corner of East Knox and Lombard Streets at 1115 East Knox Street. College president Dr. Charles Ellwood Nash constructed the home during his presidency around the turn of the 20th century. After Nash resigned, the mansion's first floor became a space shared with the music department. (Special Collections and Archives, Knox College Library.)

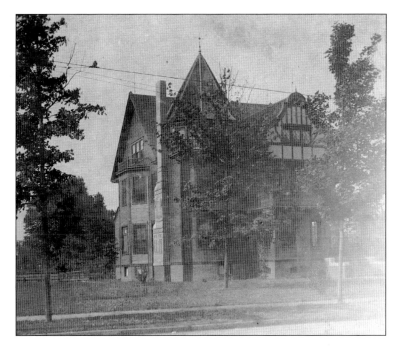

This photograph offers a peek inside the president's mansion during Dr. Nash's presidency from 1896 to 1904. There are two items of note in the image. On the far left is a framed photograph of Old Main on the wall. On the opposite side of the room, on the far right, is a portrait of Nash. (Special Collections and Archives, Knox College Library.)

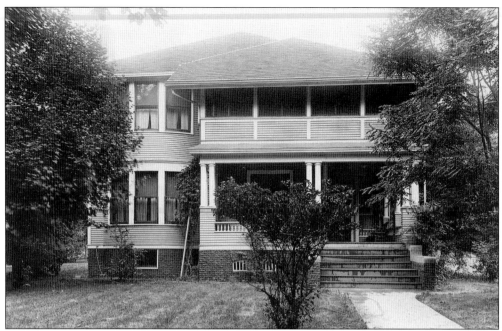

Over the years, the exterior of the president's mansion was drastically altered. The renovations in 1915–16 removed the ornate features that lined the roof during Dr. Nash's tenure. In 1927, the house became home to the newly formed fraternity Theta Nu Epsilon. After Lombard College closed, the house was razed, and a new house was built on the site around 1934. (Special Collections and Archives, Knox College Library.)

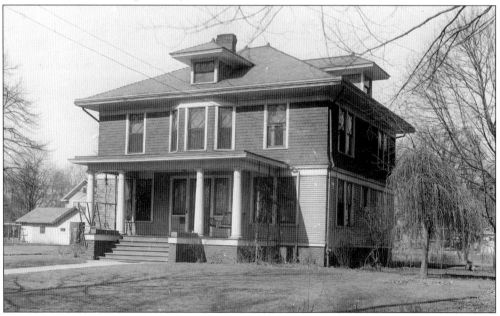

Once Theta Nu Epsilon took ownership of the original president's mansion, the president's residence was moved to neighboring 1155 East Knox Street. Only the final two presidents lived in the home—Dr. Curtis Reece and George Davis. The home was originally owned by Lombard Latin professor Dr. Frank Fowler and still stands today. (Special Collections and Archives, Knox College Library.)

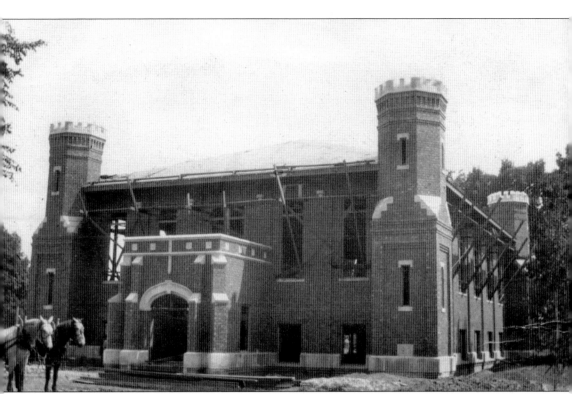

Construction of the new Lombard College gymnasium began in 1913 to the west of Lombard Field. The gymnasium became the home of physical education classes for both men and women. The gymnasium's first intercollegiate basketball game took place on January 14, 1915, against Loyola University of Chicago. The women of Lombard took advantage of the spacious new gym as well. Led by women's physical education professor Helen Hootman, the modern gym allowed for the planning and practicing of dance routines, which were at the core of their physical education curriculum. During the 1918–1919 school year, a gallery seating up to 400 people was added thanks to the donations of the alumni association. Seating was always an issue at the gymnasium, and Lombard College began playing their bigger basketball matchups at the larger Galesburg Armory. (Special Collections and Archives, Knox College Library.)

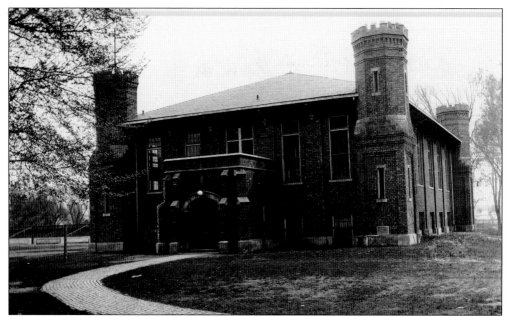

Like its predecessor, Lombard's new gymnasium was a multiuse facility. On November 19, 1915, Lombard College hosted its first annual homecoming festivities. After a day filled with reunions, parades, and football, the freshman class hosted a dance for the first time in the new gymnasium. According to the Lombard yearbook, the motto for the dance was, "We won't go home 'till morning." (Special Collections and Archives, Knox College Library.)

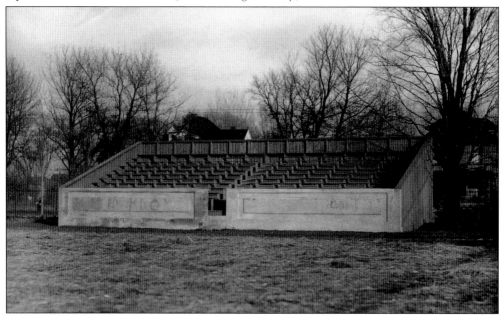

Lombard Field, home of the football, baseball, and track teams, was in the southeastern corner of campus. After the success of the 1920 football team, plans were made to create a new stadium that could hold 3,000 spectators. The football team opened the new field by dominating Palmer College of Chiropractic with a score of 102–0 on September 30, 1921. (Special Collections and Archives, Knox College Library.)

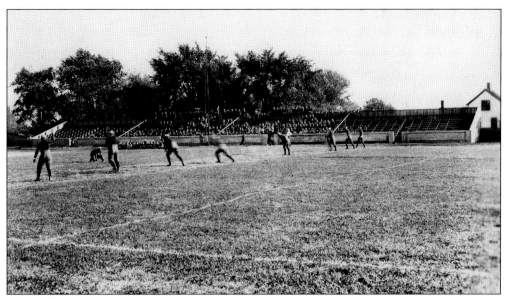

Originally, the football field faced north to south, with the north end zone almost touching Lombard Hall. However, the new stadium faced east to west. The stadium was paid for by Cyrus Yawkey, a loyal Universalist and Wisconsin businessman. Upgrades to the stadium included concrete bleachers, a new running track, and clay tennis courts. (Special Collections and Archives, Knox College Library.)

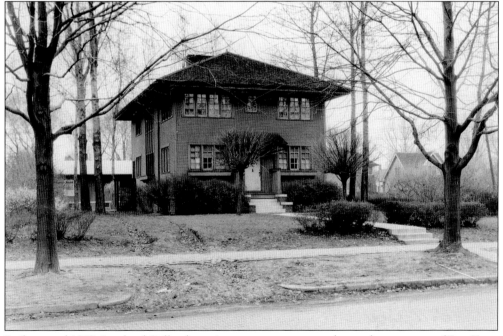

Built around 1912, Lombard College's music conservatory was on the northwest corner of East Knox and South Whitesboro Streets. On the inside, the unique building had plenty of open space and high ceilings, allowing for better acoustics. Other amenities included individual practice rooms, a music library, and the music department office. The former studio is currently a private residence at 1187 East Knox Street. (Galesburg Public Library Archives.)

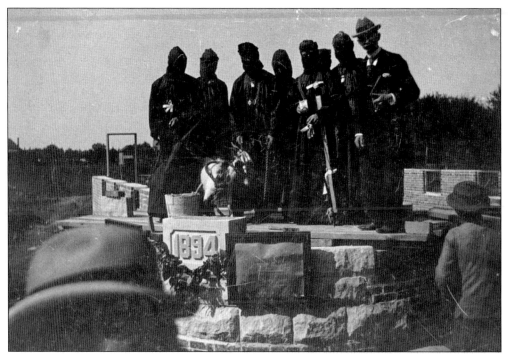

Phi Delta Theta laid the cornerstone for their new fraternity house on June 6, 1894. Several members dedicated the stone in ceremonial garb and held what was described as a "mystic ceremony." The former fraternity house is at 1335 East Knox Street, and the original 1894 cornerstone is still visible. (Special Collections and Archives, Knox College Library.)

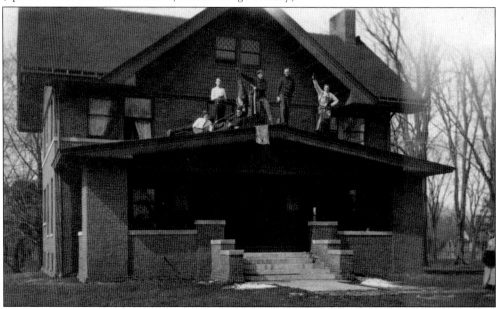

In 1908, Phi Delta Theta constructed a new fraternity house on Lombard's campus. The house was on the western side of campus close to where Park Avenue connects to Lombard Street. It would be the only fraternity house ever located directly on campus. (Special Collections and Archives, Knox College Library.)

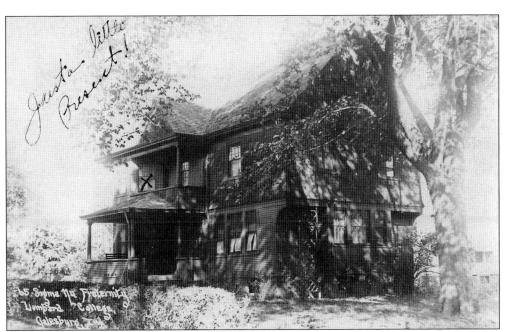

After economics professor Philip Green Wright left the college in 1912, his residence was gifted to Sigma Nu for use as a fraternity house. Fraternity members had to walk about a block and a half west to reach campus. The home is at 1443 East Knox Street and was built around 1890. (Author's collection.)

Sigma Nu constructed a larger and more improved fraternity house in 1927. The new four-story brick home overlooked campus from its western windows. With the Sigma Nu house directly across campus on the southeastern side of Locust and East Knox Streets, students had a clear view of the sorority bungalows across the street. The home is currently located at 1316 East Knox Street. (Special Collections and Archives, Knox College Library.)

The sorority bungalows were on the northeast corner of campus. From left to right are the houses of Pi Beta Phi (built in 1912), Alpha Xi (1914), and Delta Zeta (1925). The more unified location on campus made hosting social events more attractive as opposed to the scattered houses in the neighborhood that had been used previously. (Special Collections and Archives, Knox College Library.)

The ability to host and entertain were factors in the designs of the bungalows. The Alpha Xi Delta house came equipped with a large modern kitchen and dance hall on the second floor, both for guest enjoyment. In one school year, the Delta Zeta house (pictured) hosted pledge initiations, a Christmas party, a bridge party, and a sandwich shuffle. (Special Collections and Archives, Knox College Library.)

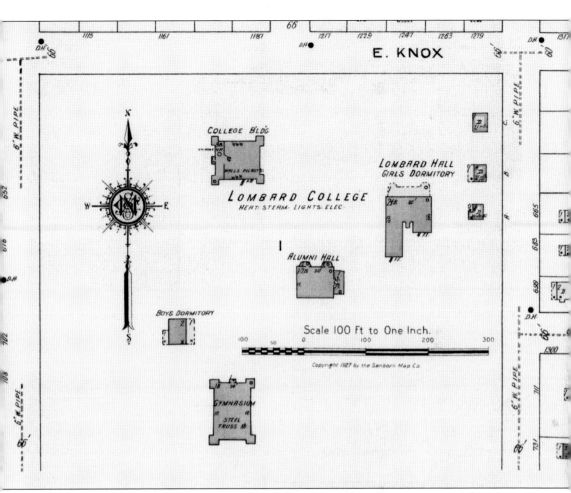

The layout of Lombard College in 1927 included all buildings the college constructed directly on campus. The building labeled as "boy's dormitory" is the Phi Delta Theta house, and the three sorority bungalows are unlabeled in the northeast corner. At the time of Old Main's construction, it was believed that Lombard Street would become a more prominent road, which was behind the decision to place Old Main's front entrance facing west. However, this assumption was incorrect, and East Knox Street, to the north, became the major road. Lombard Hall, Alumni Hall, and the Lombard gymnasium were all built facing north toward Old Main. The 1913 expansion of Lombard Hall's western wing is visible compared to the eastern wing. The blank area to the east of the gymnasium was the location of Lombard Field. This Sanborn Fire Insurance map was created by the Sanborn Fire Insurance Company in March 1927. (Library of Congress.)

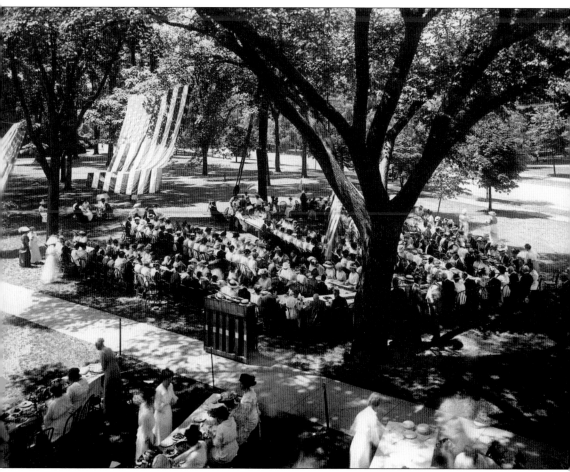

This is a view of the 1914 Lombard College reunion from the upper levels of Old Main. With its noted architecture and abundance of trees, the campus was an ideal site for picnics. Not only was it a popular site for alumni, but tourists began taking note as well, growing interested in walking the campus and visiting the famous Lombard elm. There was such demand that Lombard College created an on-campus tourist camp in 1921 to encourage traveling motorists to stop. The camp provided shelter, toilets, and showers. Lombard College president Dr. Joseph Tilden stated that in the first 10 months of its operation, the camp had housed 475 visitors. Visitors from Maine to California came to take in the sights and sounds of the campus. (Special Collections and Archives, Knox College Library.)

Two

NOTABLE FACULTY
AND PRESIDENTS

Throughout Lombard College's 79 years, many different educators passed through the doors of Old Main. Due to the school's affiliation with the Universalist Church, many college presidents either had direct ties to the church or were educated at a Universalist college. Only two of the twelve full-time college presidents were not directly affiliated with either the Universalist or Unitarian Churches. Networking within the church was important, as one of the toughest challenges for a college president was raising endowment funds. Lombard, like all colleges, needed money, and the support of churchgoers was essential to its success.

An important asset of Lombard College had always been the relationship between professor and student. Professors often became mentors, lending themselves above and beyond what the job required. Lombard College had many faculty members who met these criteria. Dr. John Van Ness Standish loaned money to his student Vespasian Warner to attend the Republican convention where Abraham Lincoln was nominated as a presidential candidate. Lombard president Dr. Lewis Beals Fisher enjoyed dining and conversing with students in the commons. Professors were even known to selflessly open their homes to host student events. Lombard president Dr. Joseph Tilden and his wife, Gertrude, hosted the annual football banquet at their house, serving the athletes a five-course meal. Even though Lombard College had its challenges, the faculty always provided a strength that the college could rely on.

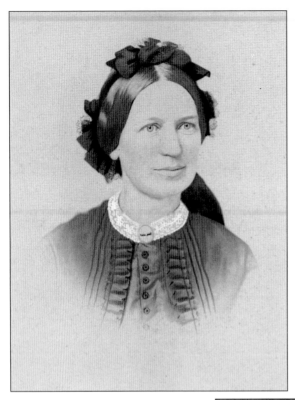

Prof. Harriet Augusta Kendall was one of the first new hires by Lombard University president Rev. Paul Raymond Kendall. She was hired as a professor of French and Italian and principal of the female department, roles she held until her resignation in 1866. During her tenure, she married her Lombard University colleague Dr. John Van Ness Standish on March 24, 1859. (Special Collections and Archives, Knox College Library.)

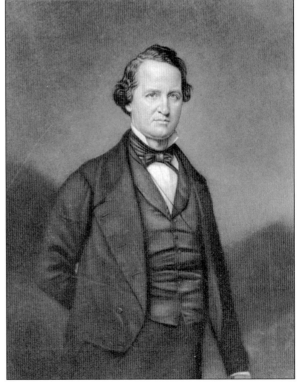

Dr. Otis Skinner, who served from 1857 to 1859, became the second full-time president. During his tenure, he represented the college at the famed Galesburg Lincoln-Douglas Debate. Lombard alumnus and Chicago businessman Harlow Higinbotham eulogized Skinner in his memoirs by stating, "He always seemed to be looking for a soul that he could cheer by loving and thoughtful words." (Special Collections and Archives, Knox College Library.)

Hired by Lombard University in 1858, Dr. Isaac Augustus Parker taught Greek and Latin for the next 50 years, retiring in 1908. Parker's students were thought to be exceptional after taking one of his courses, and students with honor-roll grades were awarded the honorary title of "Isaac Augustus Parker Scholars." (Special Collections and Archives, Knox College Library.)

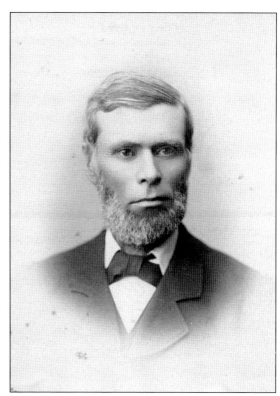

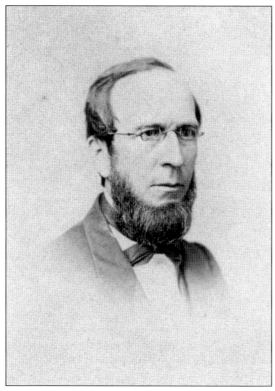

Dr. James Partelow Weston, who served from 1859 to 1872, became Lombard's third full-time president, guiding the university through the Civil War. Like many of his contemporaries, Weston was also a reverend; he previously taught at Westbrook Seminary in Maine. His biggest accomplishment as president was amending the charter to make the school a tax-free institution in 1865. (Special Collections and Archives, Knox College Library.)

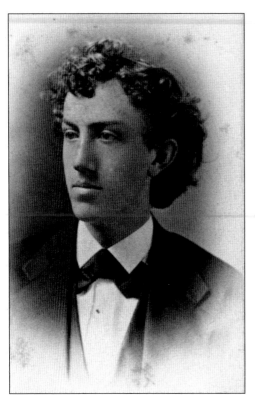

At age 22, David Starr Jordan became professor of natural history at Lombard University, a role he held from 1872 to 1873. While his time at Lombard was brief, Jordan later became president of Indiana University and founding president of Stanford University. This photograph is dated 1873 and was taken at Z.P. McMillen's New Art Gallery in Galesburg. (Department of Special Collections, Stanford University Libraries.)

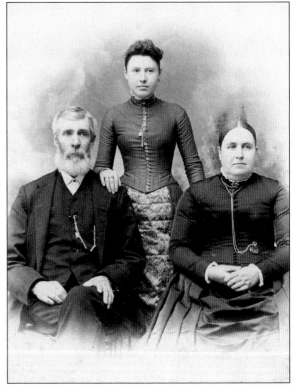

Prof. William Livingston served as Lombard University's chair of natural science from 1855 to 1872 and as acting president from 1872 to 1875. Following his presidency, he became a financial agent for the university with the goal of raising endowment funds. Livingston described religion and science as twin sisters, arguing that they were not mutually exclusive. He is pictured here with his wife, Lucinda, and daughter Emma. (Special Collections and Archives, Knox College Library.)

Dr. Nehemiah White, who served from 1875 to 1892, became the fourth full-time president of Lombard University. He previously gained experience by teaching at two other Universalist schools, Buchtel College and St. Lawrence University. White's expertise was in ancient languages—he understood French, German, Latin, and Hebrew. In 1881, Dr. White established Lombard's religious education department, which became known as Ryder Divinity School. (Special Collections and Archives, Knox College Library.)

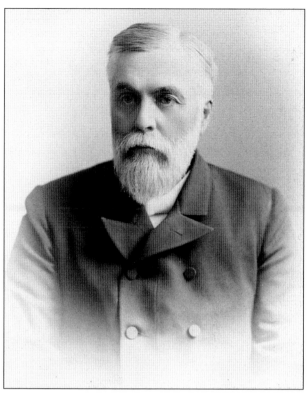

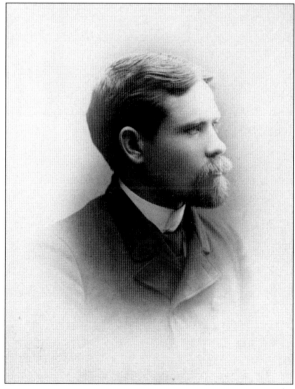

Jon Grubb briefly entered Lombard University as a preparatory student in 1872. He later returned to Lombard, receiving his bachelor's degree in 1879 and master's degree in 1882. After graduation, Grubb filled in as a professor for Dr. John Van Ness Standish, who was away on leave. When Standish returned, Grubb was offered a permanent position, which he held until 1909. (Special Collections and Archives, Knox College Library.)

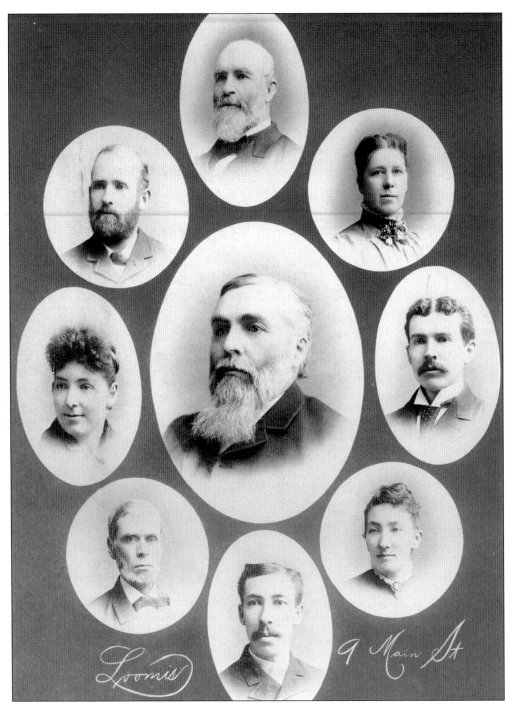

In the center of this c. 1890 photograph is Lombard University president Dr. Nehemiah White. Clockwise from top are professor Dr. John Van Ness Standish, professor Mary Claycomb-Grubb, Dr. John Clarence Lee, instructor Inez Shipman, Dr. Frederick William Rich, Dr. Isaac Augustus Parker, instructor Eleanor Stephens, and professor Jon Grubb. (Special Collections and Archives, Knox College Library.)

Mary Claycomb graduated from Lombard University with a bachelor's degree in 1868 and returned to teach French at her alma mater in 1873. While teaching, she started a relationship with her colleague Jon Grubb, and the couple were married on August 5, 1885. Carl Sandburg later fondly recalled picking apples in the backyard of the Grubb residence. (Special Collections and Archives, Knox College Library.)

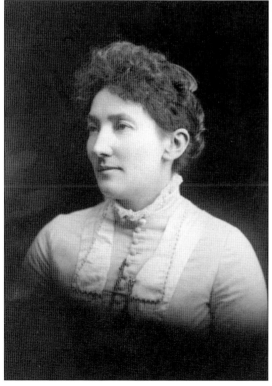

Inez Shipman began teaching English at Lombard University in 1887. Her path to Lombard was through her upbringing in the Universalist Church, where her father was part of the clergy. Shipman was a graduate of fellow Universalist school Buchtel College, and gained experience teaching in the Ohio public school system. (Special Collections and Archives, Knox College Library.)

Dr. John Clarence Lee came to Lombard University in 1884 as an English professor. He held the title of president for a few weeks in the fall of 1892 before offering it to Dr. John Van Ness Standish. Lee remarked, "The office of president is a fitting crown to Professor Standish's faithful service in Lombard University for 38 years." (Special Collections and Archives, Knox College Library.)

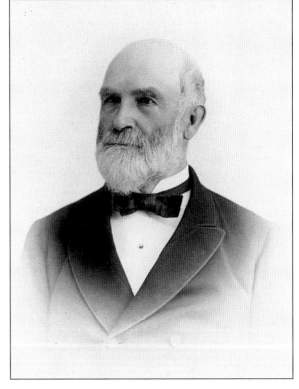

Dr. John Van Ness Standish was president in two separate stints, first as acting president in 1856 and 1857, and then full-time from 1892 to 1895, when Lombard University was in the midst of a push for modernization and expansion. In the eyes of the trustees, Standish failed to adapt, and he was pressured to resign in 1895. Standish was deeply hurt by what he viewed as betrayal. (Special Collections and Archives, Knox College Library.)

40

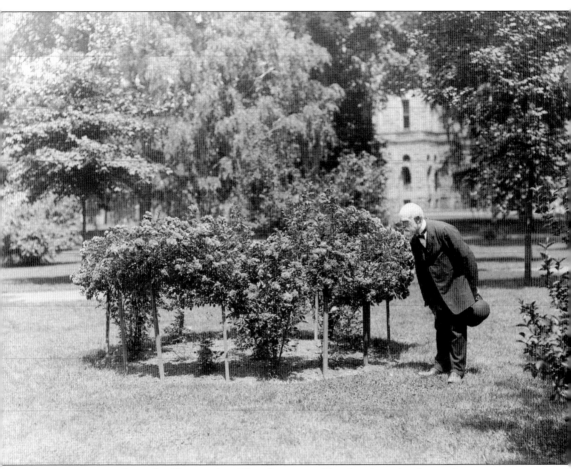

A representative from the Universalist Church went public detailing the dissatisfaction among students during Dr. John Van Ness Standish's presidency. Standish felt it was an unnecessary attack on him as a person, and defended himself by pointing out how much he labored and donated to the university over his 41 years of service. Standish stated, "If it had not been for two men, there would have been no university." Angered, Standish filed a lawsuit against the university for back pay. He had originally donated his salary for 1894 and 1895 to the university for the building of a female dormitory. In 1897, the lawsuit was settled in Standish's favor, earning him a payout of about $1,300. The feud was not finished, however. In 1909, Standish donated his entire estate to crosstown rival Knox College. Carl Sandburg imagined in his autobiography, *Ever the Winds of Chance*, that Standish's last words were, "All that I have and am, I give to Knox. I have forgotten the name Lombard if I ever knew it." (Galesburg Public Library Archives.)

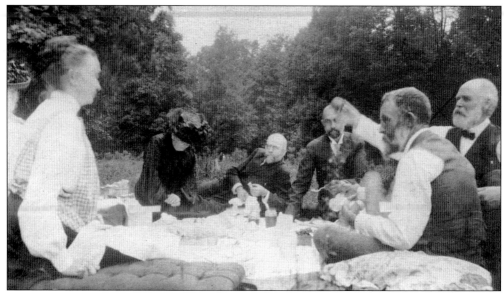

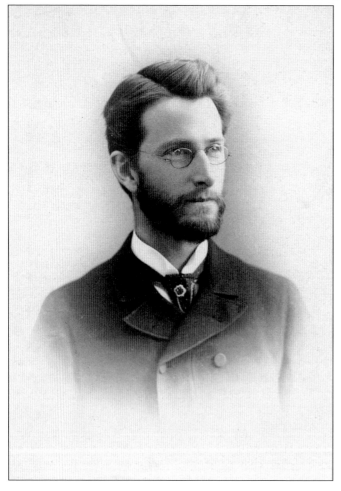

At this picnic of professors in 1904, Dr. John Van Ness Standish is seated at far right. Even though his presidency ended in turmoil, Standish still had many friends within the community. Outside of work, Dr. Standish was a noted horticulturist and was given credit for planting much of the greenery on Lombard College's campus. (Special Collections and Archives, Knox College Library.)

Prof. Philip Green Wright was hired by Lombard University in 1892 to teach mathematics and economics. However, he is more known for starting the Poor Writers Club, which met every Sunday at his house. The club began critiquing literature but eventually grew into members writing their own poetry and stories. Lombard student Carl Sandburg was a proud member of the club. (Special Collections and Archives, Knox College Library.)

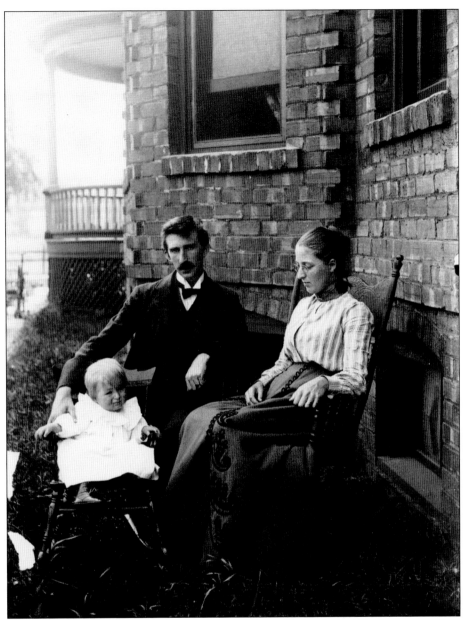

The contributions to Lombard College made by professor Philip Green Wright are countless. He published his former student Carl Sandburg's first set of poems, *In Reckless Ecstasy*, in 1904, printed with his personal printing press, known as the Asgard Press. All three of his sons—Sewall, Quincy, and Theodore—graduated from Lombard. Wright even penned the "Lombard Hymn," which went, "Lombard, thy heralds we, speaking thy victory, go forth with might; strong in thy mission clear, dispelling far and near, darkness and doubt and fear, with God and light." Upon leaving the college in 1912, Wright gifted his former home to be used as the Sigma Nu fraternity house. He was welcomed back at Lombard College's 1930 midyear commencement, where he was presented with an honorary doctor of laws degree. Here, Wright and his wife, Elizabeth Quincy Sewall, are pictured outside their home with one of their children. (Special Collections and Archives, Knox College Library.)

Dr. Charles Ellwood Nash, who served from 1895 to 1904, was elected president following the resignation of Dr. John Van Ness Standish. Nash was a member of the church who previously served as a Universalist pastor in Brooklyn, New York, and an 1875 graduate of Lombard University. The direction to Nash from the trustees was to expand the campus with modern amenities. At the time, Old Main was still the only building on campus. Nash quickly approved the construction of Lombard Hall, the gymnasium, and the president's mansion. During his presidency, Nash oversaw the college's first attempt at a student government, which ended up lasting less than two years, and guided Lombard's transition from a university to a college in 1900. Nash's personality was that of a preacher, and he routinely spoke out against controversial topics, including alcohol, war, and lynching. (Unitarian Universalist Photograph Collection, bMS 900/34. Andover-Harvard Theological Library, Harvard Divinity School.)

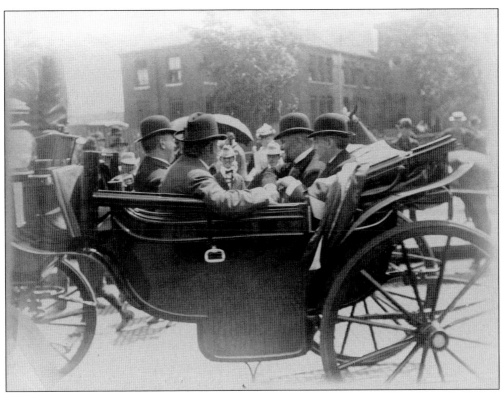

Lombard College's 50th anniversary parade took place on June 5th, 1901. Pictured in the carriage from left to right are Lombard College president Dr. Charles Ellwood Nash, attorney Forrest Cooke, US ambassador Edwin Conger, and local physician William Bradley. Their car paraded through the streets of Galesburg, which were decorated in the Lombard colors of olive and gold. A banquet to celebrate the occasion was held on campus with around 600 guests. (Galesburg Public Library Archives.)

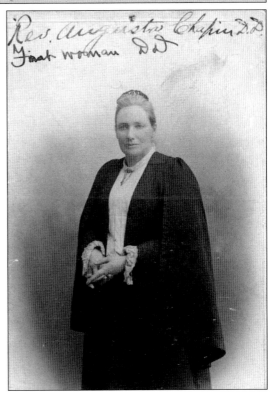

Augusta Jane Chapin, a well-known Universalist minister, served Lombard University as a nonresident lecturer in the 1890s. Her role included visiting campus several times a year to present lectures. Lombard awarded her an honorary master's degree in 1869 and an honorary doctor of divinity in 1893—the first ever awarded to a woman. (Unitarian Universalist Photograph Collection, bMS 901. Andover-Harvard Theological Library, Harvard Divinity School.)

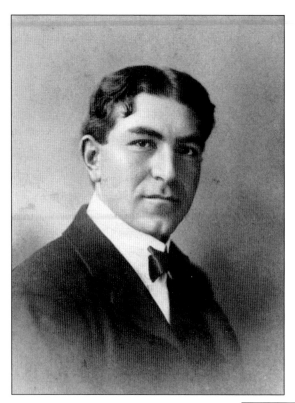

Athletics were rapidly evolving at the time when physical director Willis Kienholz was hired in 1903. While he was primarily hired to teach physical education, Kienholz also coached the football team. Exercise and student health activities were gaining importance nationwide. During his sole season as coach, Kienholz led the football team to a 4–3 record. (Special Collections and Archives, Knox College Library.)

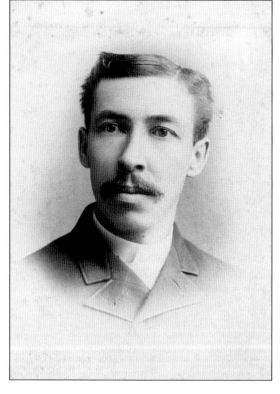

When Lombard president Dr. Charles Ellwood Nash resigned in 1904, the college appointed Dr. Frederick William Rich as acting president, and he served in that role until 1905. Hiring an individual who knew Lombard College well became crucial, as the college was experiencing financial issues. Rich began teaching science courses at Lombard in 1884 and continued to do so until his resignation in 1911. (Special Collections and Archives, Knox College Library.)

Dr. Lewis Beals Fisher, who served from 1905 to 1912, was elected president amidst financial hardship for the college. At the time, options were being weighed about whether moving or merging with another institution would make the most sense for Lombard's survival. Under Fisher's guidance, Lombard College remained indecisive about the future. Perhaps his biggest success as president was securing a $25,000 donation from philanthropist Andrew Carnegie. (Special Collections and Archives, Knox College Library.)

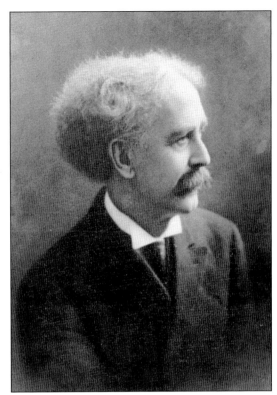

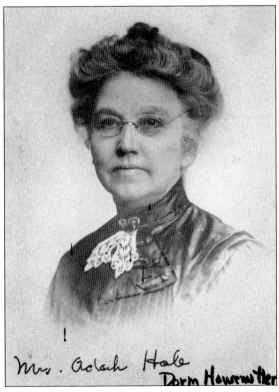

Mrs. Adah Hale
Dorm Housemother

Adah Hale held the title of dean of women and matron of Lombard Hall. Her duties included overseeing the health and well-being of female students, enforcing college rules, and accepting dormitory applications. The matron was required to live in the hall amongst the students. (Special Collections and Archives, Knox College Library.)

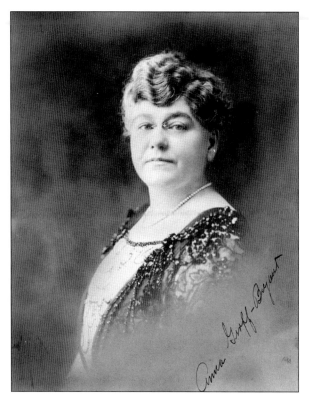

Noted Chicago vocal arts teacher Madame Anna Groff-Bryant moved her vocal program to Lombard College in 1912. Groff-Bryant originally opened her Chicago music institute in 1904 and became well known for her research in the field. She was a strong advocate for vocal arts being included in college education. (Special Collections and Archives, Knox College Library.)

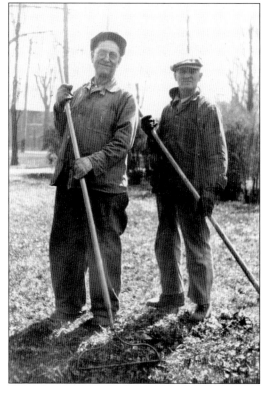

Two handymen pose with their rakes on Lombard College's campus. Lombard had many lesser-known employees who served the college in smaller roles. The countless handymen kept the college in working order and maintained its ornate landscape. (Special Collections and Archives, Knox College Library.)

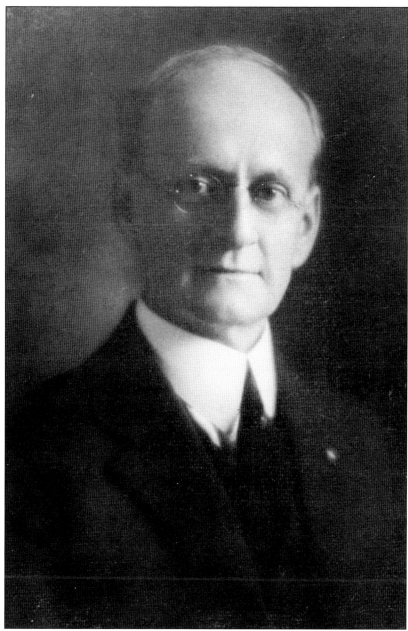

Dr. Joseph Tilden, who served from 1916 to 1928, was elected president after working for the New York City Department of Education for 15 years. Tilden had a skill for fundraising and did not hesitate to pull his car over if he saw a potential donor, to the dismay of local police. He was cited several times for illegal parking during these fundraising endeavors. Tilden's dedication to the college extended to his personal time. He began writing magazine articles for extra money on the side, but since the job of a college president is an around-the-clock affair, he began to feel guilty. Therefore, he established the Tilden Loan Fund, giving his extra money to aid Lombard College students in need. On campus, Tilden was beloved by students, and he openly admitted that he preferred talking to students over professors. Unfortunately, he passed away in 1928, perhaps when the college needed him most. (Special Collections and Archives, Knox College Library.)

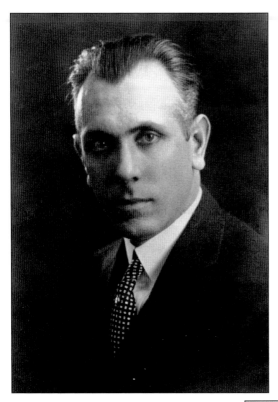

Dr. Curtis Reece, who served from 1928 to 1929, became the first Unitarian president after the Unitarian Church purchased a stake in the college. When he began his presidency, Reece was serving as secretary of the Unitarian Conference, which he tried to balance with his newfound duties as president. The workload of both jobs proved too much, and he resigned from Lombard to focus full-time on the Unitarian Conference. (Special Collections and Archives, Knox College Library.)

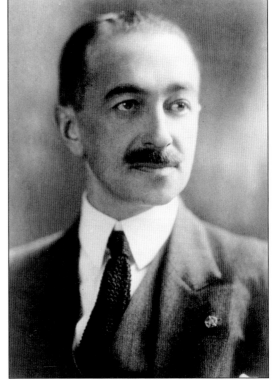

Harvard-educated businessman George Davis, who served from 1929 to 1930, was the last president of Lombard College. He had ties to the Unitarian Church and served as the church's executive secretary. Davis tried to keep Lombard alive through a merger with Knox College, which ultimately failed. The responsibility of selling the campus then fell on Davis, who reached a deal with the Galesburg Board of Education. (Galesburg Public Library Archives.)

Three

THE LOMBARD SPIRIT

For a majority of Lombard College's existence, the student population was made up of three departments: preparatory (high school), college, and divinity. Upon entering the college, students were free from any religious testing, allowing them to be from any faith. In the 1800s, Lombard University offered the standard courses of the era, including philosophy, Latin, Greek, and the natural sciences. As Lombard College evolved in the 1900s, more vocational classes were offered, including home economics, business, education, and profession-based courses.

Outside the classroom, the Lombard College student had several ways to get involved with campus life. Students could join fraternities, sororities, and a variety of on-campus clubs. The *Stroller* yearbook and *Lombard Review* newspaper were written and edited by students. Social events like homecoming became some of the biggest events on the calendar. Each class elected its own student officers, including a president, secretary, and treasurer. Perhaps the most important social events at Lombard were the daily meals served in Lombard Hall to both students and faculty, leading to many great conversations and friendships.

The tale of the Lombard Spirit can be read about in various Lombard College pamphlets. It was said that the spirit could be felt by students in various ways, whether it was admiring the poplar trees that lined the sidewalk to Old Main, letting out a cheer at a big football game, or helping a fellow student in need. Lombard College felt that for students to be successful, they needed to have this spirit in one way or another.

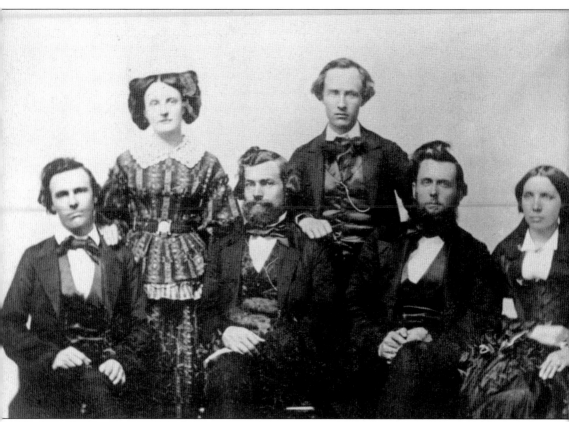

Lombard University awarded its first bachelor's degrees to the class of 1856. The graduates were Lucy Adaline Hurd (second from left), Jennie Miles (far right), and, in unknown order, William Worth Burson, William Remy Cole, Thompson McNeely, and Louis Alden Simmons. Lombard University's first class went on to achieve a variety of accomplishments. Burson's inventive skills led to him taking a prominent role in the knitting industry in Rockford, Illinois. Cole founded Cole Brothers, a business selling pumps and lightning rods in Mount Pleasant, Iowa. After completing his bachelor's degree, McNeely earned his law degree at the University of Louisville, then practiced law in Petersburg, Illinois, and was later elected to the US House of Representatives, where he served from 1869 to 1873. Simmons served as a judge and resided in Wellington, Kansas. Hurd married Canadian railroad tycoon William Cornelius Van Horne. (Special Collections and Archives, Knox College Library.)

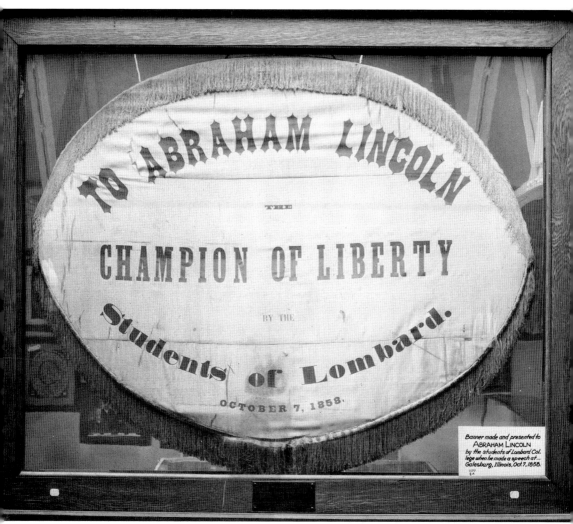

Banner made and presented to ABRAHAM LINCOLN by the students of Lombard College when he made a speech at... Galesburg, Illinois, Oct.7, 1858.

On October 7, 1858, Knox College hosted the biggest event in Galesburg history—one of the famed Lincoln-Douglas debates. Lombard University made sure its presence was felt at the event. The banner pictured here was created by students and transported to the debate in Lombard University president Dr. Otis Skinner's carriage. Two fortunate Lombard students, Eliza Carr and Mary Pike, had the honor of presenting the banner directly to Abraham Lincoln. The banner was later gifted by Mary Todd Lincoln to family friend and US district judge Mark Delahay. In 1877, the banner was donated to the Kansas State Historical Society, where it resides today. Lombard alumnus Laura Lavinia Pike-McConnell (class of 1864) had an exact replica of the banner created and donated it to Lombard College in 1914. The replica is now on display at Knox College's Seymour Library. (Special Collections and Archives, Knox College Library.)

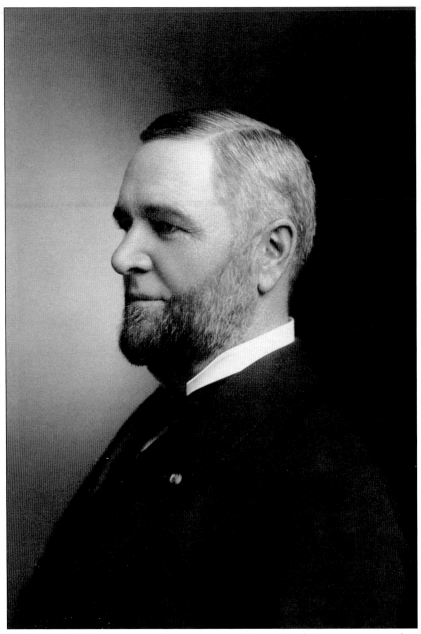

US ambassador, Civil War veteran, and congressman Edwin Hurd Conger was a graduate of the Lombard University class of 1862 and later married fellow student Sarah Pike (class of 1863). Over his career, Conger traveled the world, serving the United States in diplomatic roles in Brazil, China, and Mexico. Conger maintained a close relationship with Lombard University, returning on several occasions. He first returned in 1883 for his 25-year class reunion; they had been nicknamed the "war class," as most of them enlisted in the Civil War. In 1901, Conger was the guest of honor at Lombard College's 50th anniversary, where he was presented with an honorary doctorate. Upon receiving the doctorate, Conger acknowledged several colleges were offering him honorary degrees, but the one he prized the most was the one awarded to him by his alma mater. (Special Collections and Archives, Knox College Library.)

The earliest organized extracurricular activity for students was a literary society. In 1863, the women of Lombard University formed the Zetecalian Society, a debate and essay-writing club. An annual public debate called the Townsend Prize Contest started in 1885 and gave members the chance to compete for a cash prize. Members of the 1870 club are pictured here. (Special Collections and Archives, Knox College Library.)

The Philomathian Society was open to all male preparatory students who wished to write essays and engage in debates. The society traced its roots to the University Debating Society, which formed in 1858 and rebranded as the Philomathian Society in 1860. Weekly meetings were held in Dr. Isaac Augustus Parker's classroom. This image shows the 1885 club members. (Special Collections and Archives, Knox College Library.)

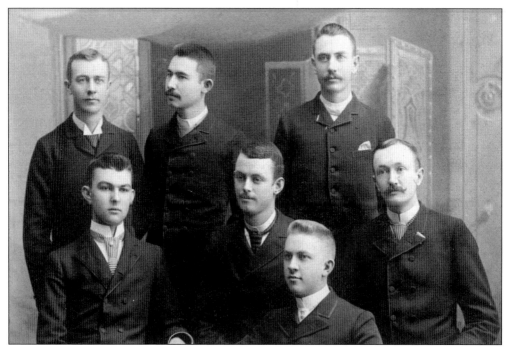

Lombard University's third literary society, the Erosophian Society (above), was open to collegiate men. The society formed in 1860 through the consolidation of two previous clubs, the Alhenian and Autokeleuthii Societies. Members chose the new name, which translates as "the desire for wisdom" in Greek. Much like the Zetecalian Society's Townsend Prize Contest, the Erosophian Society hosted a debate contest known as the Swan Prize Contest. The first was held in 1885, when the winner received a prize of $15, and second place received $10. Below is the third annual Swan Prize Contest, held on February 5, 1888. (Both, Special Collections and Archives, Knox College Library.)

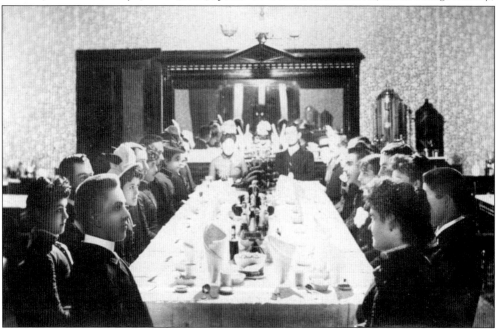

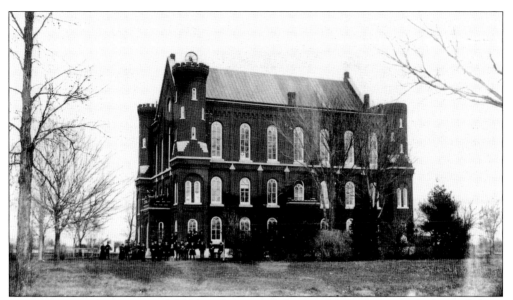

From 1852 to 1878, an estimated 5,000 students enrolled at Lombard University, which awarded 148 bachelor's degrees in this time. A large portion of the students were in the preparatory department, resulting in the disparity between students and degrees earned. The collegiate department finally began enrolling more students than the preparatory department during the 1885-1886 academic year. During the 1875 school year (pictured), Lombard had about 100 students. (Author's collection.)

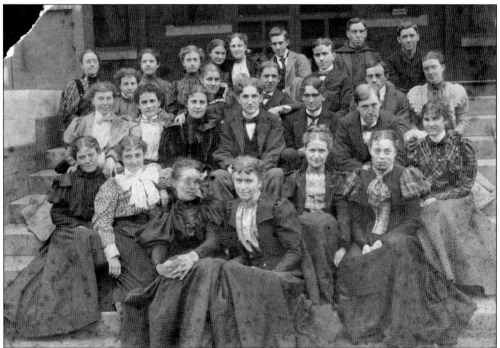

Students in the Lombard University era had only three options to earn a bachelor's degree—classical, scientific, and literary, all of which had designated courses from which students could not deviate. It was not until the 1894-1895 school year that students were allowed to take elective courses. This image shows students in 1889. (Special Collections and Archives, Knox College Library.)

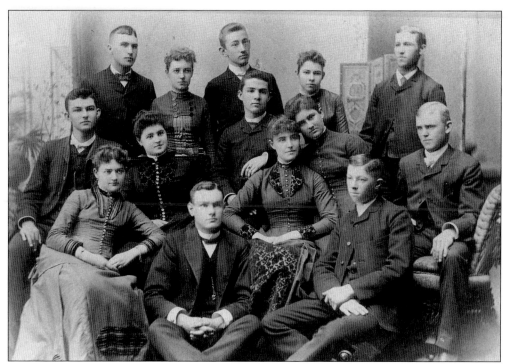

These two photographs show the progression of the Lombard University class of 1890. Pictured above during freshman year are, from left to right, (first row) Della Rogers, Charles Mortimer, and Richard Slater; (second row) Samuel Harsh, Lillian Wiswell, Loring Trott, Mildred ?, Elizabeth Durston, and Edward Miles; (third row) Claude Anderson, unidentified, Allen Moore, Lizzie Wigle, and Robert Hill. The students are seen below in their senior year. Note the changes in the students. From left to right are (first row) Jennie Grubb, Wigle, Trott, Annie Yeomans, Wiswell, Durston, and Moore; (second row) unidentified, Slater, Hill, James Welsh, Harsh, Burtrust Wilson, and Anderson. (Both, Special Collections and Archives, Knox College Library.)

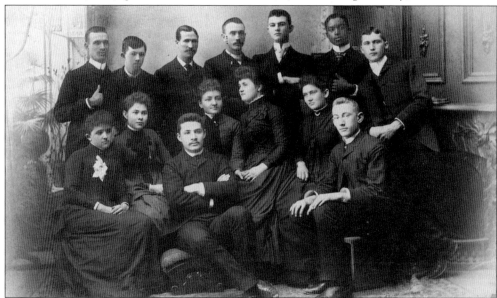

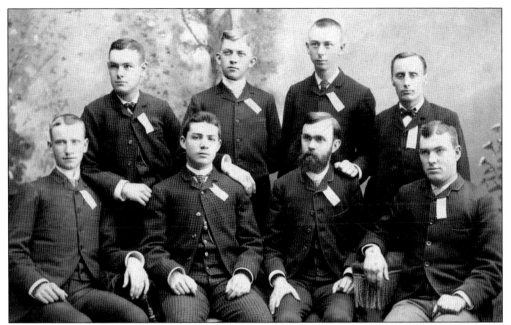

One unique boarding club from the Lombard University era went by the name of the Mighty Masculine Masticators Club, which existed "for the purpose of obtaining a little pleasure in life and to increase interest in eating." The c. 1889 members pictured here are, from left to right, (first row) unidentified, Loring Trott, professor Jon Grubb, and unidentified; (second row) Charles Mortimer, Edward Pike McConnell, Frank Fowler, and unidentified. (Special Collections and Archives, Knox College Library.)

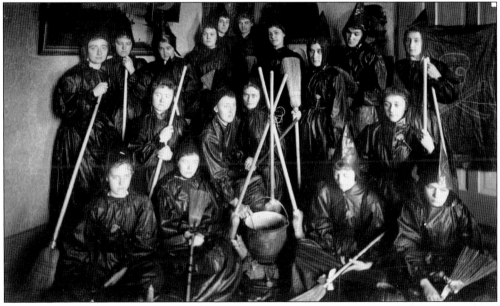

The women of the Pine Street Boarding Hall dressed as witches for Halloween 1892. After students moved into the newly built Lombard Hall in 1896, the Pine Street Boarding Hall was split in half and divided into two houses. Both halves are currently private residences located at 662 and 682 Pine Street. (Special Collections and Archives, Knox College Library.)

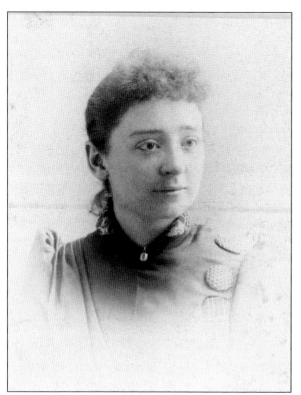

Ethel Mae Tompkins (class of 1893) was a highly decorated student who served as freshman class president and was a member of both Pi Beta Phi and the Zetecalian Society. She came from the small town of Avon, Illinois, with her sister Nellie Tompkins (class of 1895) to study at Lombard University. The siblings later donated $50,000 in their parents' names to create Tompkins Science Hall. (Special Collections and Archives, Knox College Library.)

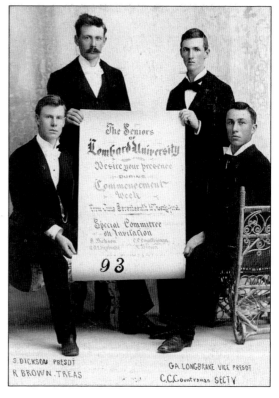

Lombard University seniors from the class of 1893 advertise the annual commencement ceremony. From left to right are Richard Brown, States Dickson, Guy Longbrake, and Carl Countryman. The festivities took place in the college auditorium and featured a variety of student speeches. Three students from the liberal arts department and two from the Ryder Divinity School were chosen to speak based on grades, thesis quality, and speaking ability. (Special Collections and Archives, Knox College Library.)

Future Pulitzer Prize–winning poet Carl Sandburg attended Lombard College from 1898 to 1902. As a child, a barefoot Sandburg enjoyed exploring the halls of Old Main, taking in the natural history displays and watching commencement exercises. After one ceremony, Dr. John Van Ness Standish spotted the barefoot Sandburg, but instead of giving him a scolding, Standish smiled and patted Sandburg on the head. The Galesburg native entered Lombard College as a non-degree-seeking student. In his collegiate career, he held the position of business manager for the *Lombard Review* from 1899 to 1900 and was editor from 1901 to 1902. The young writer also won the Swan Prize Contest in 1901. In 1923, Sandburg returned to Lombard and received an honorary doctorate of letters. (Both, Rare Book & Manuscript Library, University of Illinois at Urbana-Champaign.)

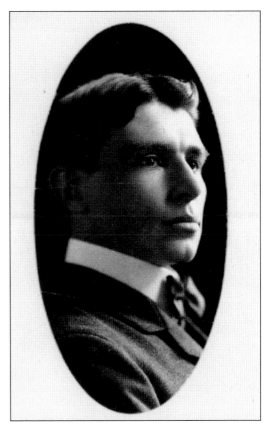

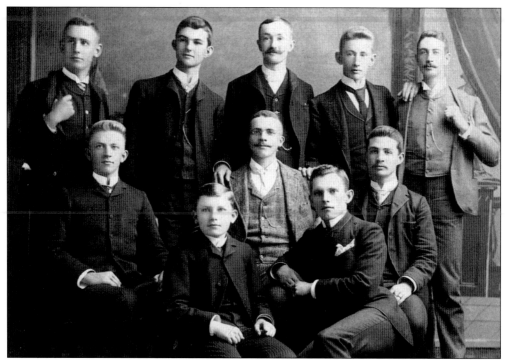

The Phi Sigma League, the first fraternal organization at Lombard University, was established in 1857. After the league's popularity waned, it was absorbed into Phi Delta Theta in 1878. Phi Delta Theta fraternity members are pictured here around 1888. From left to right are (first row) George Harrison and Percy Hale; (second row) Edward Pike McConnell, Vernon Smith, and Loring Trott; (third row) unidentified, Samuel Harsh, George Dutton, Allen Moore, and unidentified. (Special Collections and Archives, Knox College Library.)

While being a member of a fraternity offered students boarding, camaraderie, and connections, many fraternity members still had to work their way through college. This undated photograph shows a group of Lombard University Phi Delta Thetas digging with shovels. The photograph is labeled "the shovel degree," making light of their hard work. (Galesburg Public Library Archives.)

Set against the backdrop of Old Main, Phi Delta Theta members are pictured above in 1890. Edward Pike McConnell (first row, far left) knew the traditions of Lombard University well. He was the son of Lombard alumnus Laura Lavinia Pike McConnell and nephew of Sarah Pike Conger (page 53). Below, Phi Delta Theta members pose at their annual stag party on October 5, 1904, at their chapter house. Social gatherings were an essential part of fraternity life. Phi Delta Theta hosted two annual parties—a stag party celebrating the chapter's birthday each fall, and a more traditional event in the spring with invited guests. (Both, Special Collections and Archives, Knox College Library.)

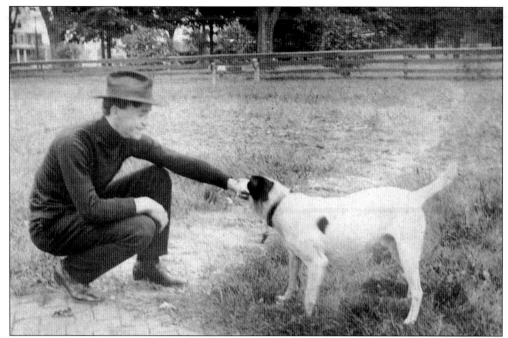

Above, a Phi Delta Theta member plays with the "frat pup" on October 8, 1904. Below are the 1904 Phi Delta Theta members. John Conrad Weigel, at far left in the second row, was a Joliet native and graduated in 1908. He was the winner of the 1907 Swan Prize Contest for his oration titled "Luther." His communication skills earned him the honor of speaking on behalf of his class at commencement. After graduation, Weigel taught German at the University of Chicago and later held several administrative roles within the US government. (Both, Special Collections and Archives, Knox College Library.)

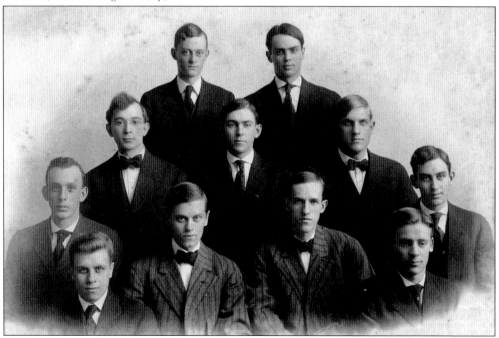

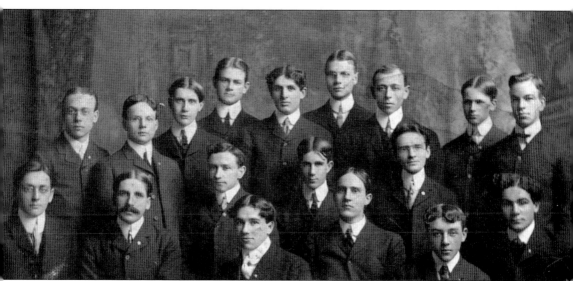

The origins of Sigma Nu go back to 1867, when the fraternity was founded as Delta Theta. It operated independently with no national fraternal ties until becoming associated with Delta Tau Delta in 1869. After a series of disagreements, the affiliation was terminated in 1885. The fraternity returned to independent status until it became affiliated with Sigma Nu in 1891. While at Lombard College, the fraternity moved several times; one of its earliest traceable homes is at 730 Pine Street, which was the Sigma Nu house in 1905. The final house was built in 1927 (page 29). It saw little use after Lombard closed in 1930. Knox College students continued to live there until 1932, when a house was constructed closer to the Knox College campus. (Special Collections and Archives, Knox College Library.)

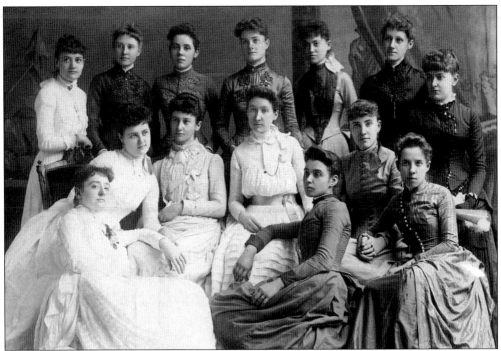

Pi Beta Phi, the first sorority at Lombard University, was founded in 1872. A charter member of Lombard College's Pi Beta Phi chapter, Sara Richardson was present at the formation of an important tradition. She attended the sorority meeting where University of Kansas chancellor John Fraser complimented the sorority's baking as a "Cookie Shine." The name stuck, and the tradition of baking cookies is still practiced today by Pi Beta Phi. Pictured above are the 1887–1888 Pi Beta Phi members. From left to right are (first row) Ethel Tompkins, Anna Ross, and unidentified; (second row) Lillian Wiswell, Ella Grubb, Carrie Rice, and Mildred Woods; (third row) Della Rogers, Lizzie Bliss, unidentified, Alvia Myers, Laura Sofield, unidentified, and Emma Livingston. Below, a group of Pi Beta Phis stand on the steps of their sorority bungalow. (Both, Special Collections and Archives, Knox College Library.)

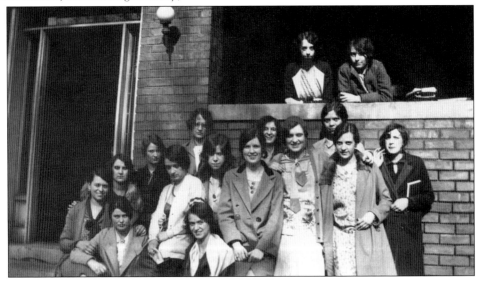

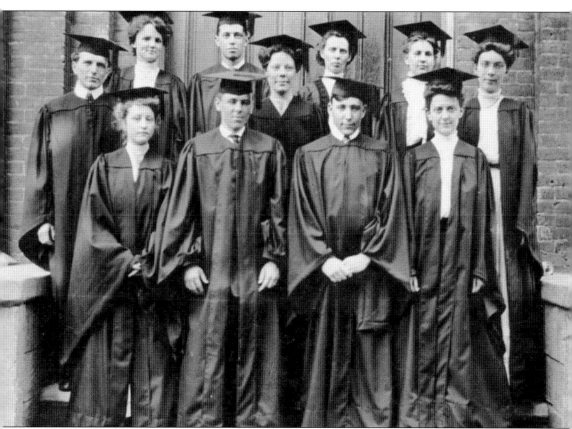

The Lombard College class of 1907 is shown proudly standing on the steps of Old Main. The weeklong commencement festivities kicked off on Monday with the annual field day and Townsend Prize Contest. Thursday was commencement day, which featured speeches from top students of the class followed by the alumni banquet in the gymnasium. The tone at commencement varied depending on who was president. President Dr. Lewis Beals Fisher enjoyed tapping into his preaching background and often spoke about morality during commencement. Fisher once stated at commencement, "Many college men and women are not as good as society has a right to expect. Nearly all the men and women in high places who, last year, were convicted of graft are educated. Trained man, with sharpened intellect like an ungoverned mogul engine, can work great harm." (Special Collections and Archives, Knox College Library.)

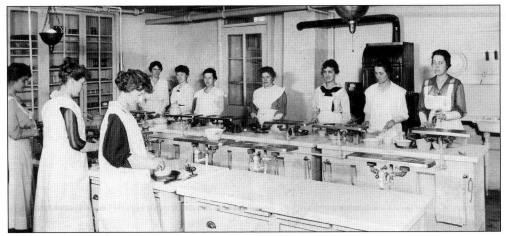

As Lombard College opened itself to more career-focused and vocational education, it shied away from its equal-opportunity roots. Home economics was directly marketed to female students, offering them a chance to learn how to budget, take care of children, and plan meals. This image offers a glimpse of a home economics class in the basement of Old Main in 1918. (Special Collections and Archives, Knox College Library.)

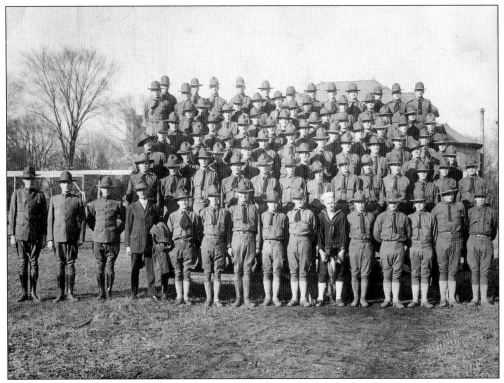

World War I brought challenges to colleges across the United States that had not been felt since the Civil War. Young college men quickly found themselves preparing for war. The federal government started the Student Army Training Corps (SATC), which let students continue taking college courses simultaneously with military training. Lombard College's SATC unit is pictured around 1918. (Special Collections and Archives, Knox College Library.)

Lombard College president Dr. Joseph Tilden stands with commanding officers Lieutenant Price, Lieutenant Scoggins, and Lieutenant Tibbee. Two casualties during the war affected Lombard. Alumni Carl Rosequist and Orville Winter were killed in action in France in 1918. Rosequist, an Evanston native, was a three-sport athlete at Lombard, playing football, basketball, and baseball. (National Archives, catalog photo No. 165-WW-107M-2.)

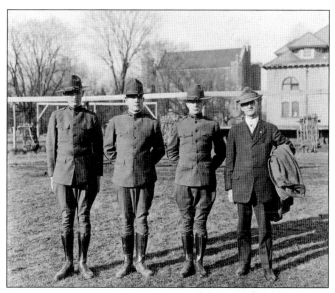

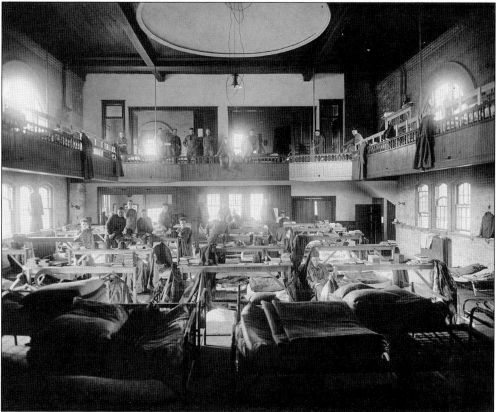

During World War I, Lombard College's campus became a miniature military base. The once-peaceful green spaces on campus transformed into obstacle courses for bayonet run training. Alumni Hall became a barracks for students (pictured). After the armistice was reached on November 11, 1918, the Student Army Training Corps was disbanded, and life at the college returned to normal. (National Archives, catalog photo No. 165-WW-107M-4.)

An early Lombard College tradition was participation in class fights, which originated in 1858. The tradition was not exclusive to Lombard, as the violent class-on-class warfare took place at many colleges. The most dangerous incidents in Lombard's history involved battling to hang class colors from the roof of Old Main. An 1898 incident led to a senior student pulling a gun while defending the roof, remarking, "If you get those colors, it is over my dead body." President Nash was made aware of the circumstance and raced to intervene. In the end, 14 students were suspended, and 2 were expelled. Finally, in 1923, students voted to end the tradition, agreeing instead to face off in athletic competitions, including boxing and tug-of-war. (Both, Special Collections and Archives, Knox College Library.)

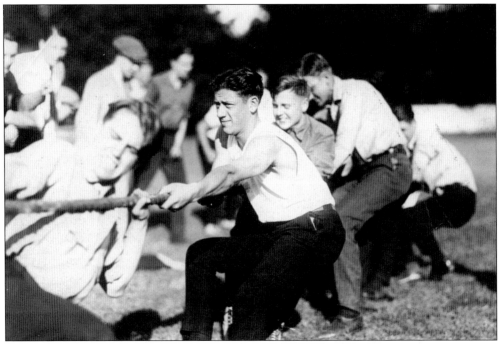

Even though he was a football star, quarterback Roy Lamb (right) was not exempt from attending classes. The native of Lincoln, Nebraska, pictured with books in hand, was a member of Phi Delta Theta and the class of 1925. Walking with Lamb is Edward Flink, a Sigma Nu member who played basketball and baseball. (Special Collections and Archives, Knox College Library.)

The women of Lombard College were not immune to pulling pranks on each other. One night, two female students dressed as men broke into Lombard Hall, posing as burglars. The fake burglars were hoping to get a scare out of their roommates. However, they were chased out of the hall by girls armed with hatpins. (Special Collections and Archives, Knox College Library.)

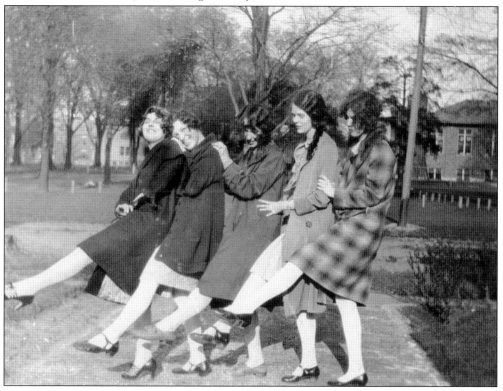

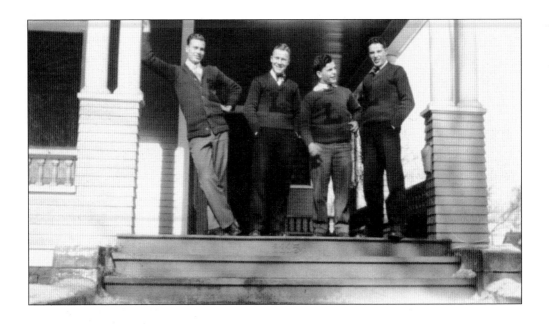

Pictured above are Lombard College men standing on the steps of their fraternity house. Below, a student enjoys the relaxing views of campus with Tompkins Science Hall and the Lombard gymnasium in the background. As young adults, Lombard students were still developing their judgment skills, which often had unintended consequences. In 1924, a couple of students went on a hunting trip. One proudly captured a badger alive. To prove it, he decided to bring it back to campus, where he tied it up outside and went to bed. The next morning, he awoke to a terrible smell, and after smelling his clothes and hands, realized he had captured a skunk. (Both, Special Collections and Archives, Knox College Library.)

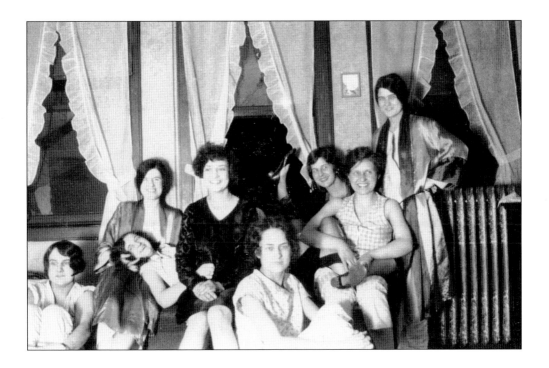

Lombard College was progressive in terms of coeducation, but the college still imposed strict dating rules between students. Early college catalogs in the 1880s banned dancing, visiting a room of a member of the opposite sex, or walking together. In 1898, President Nash banned courting in any form. By 1907, President Fisher decreed that students were allowed to dance as long as they were both Christians. Over the years, countless marriages occurred between Lombard students, leading to the belief that not many fully abided by the rules. These images show the women of Lombard Hall (above) and a group of students strolling on campus with Old Main in the background (below). (Both, Special Collections and Archives, Knox College Library.)

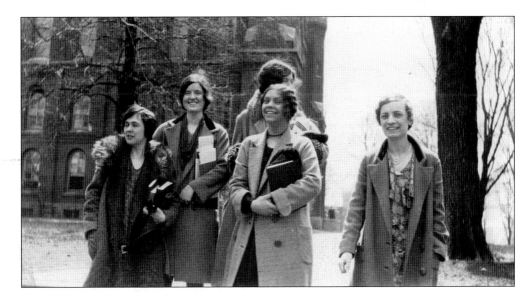

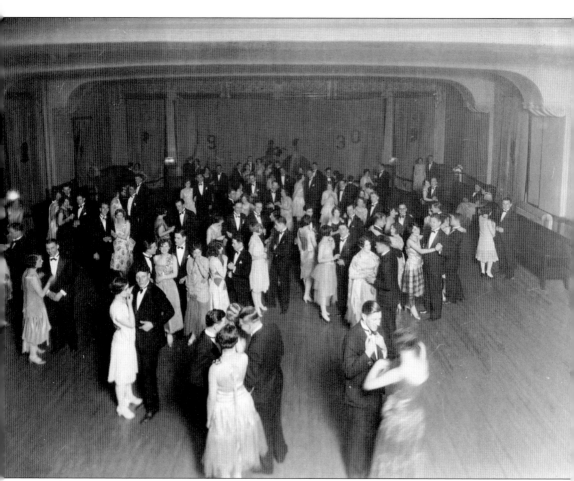

Dancing and dating restrictions eased in the college's final years, with annual dances as evidence. The junior prom was held in the Galesburg Knights of Columbus Hall on March 8, 1929. A band known as Jack Wright and his Ohioans provided the music, while silhouettes of old-fashioned gentlemen and ladies decorated the walls. Upon entry, guests met a receiving line that started with Miss Lombard (Alice Ward) and ended with college president George Davis. After a night filled with dancing, the event was capped off with confetti and streamers. The dance was planned by students, and a social committee was created to carry out tasks. The 1929 event was led by chairman Joseph Reed and Betty Gould. Decorations were planned by Elizabeth Thomas, Richard Johns, Geraldine Dalton, and Daisy Falkenstein. (Special Collections and Archives, Knox College Library.)

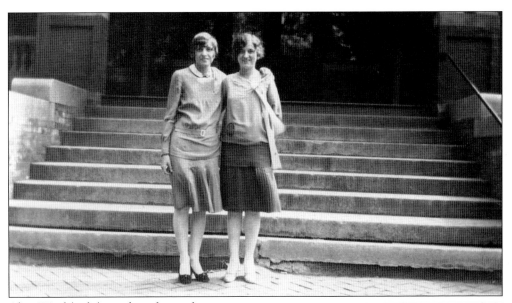

Alice Ward (right) stands in front of Lombard Hall with a friend around 1930. Student involvement in campus activities varied from person to person. Ward wasted no time at Lombard College—she was the junior class president, elected Miss Lombard, a member of Pi Beta Phi, the college council president, and played basketball and floor hockey. (Special Collections and Archives, Knox College Library.)

Students, like the ones pictured here, had to purchase school supplies, snacks, and postage in downtown Galesburg until the Wel Kum Inn opened its doors across the street from campus in 1914, adding much convenience. The store opened a larger building in 1925 at 1217 East Knox Street; it has since been converted into a home. (Special Collections and Archives, Knox College Library.)

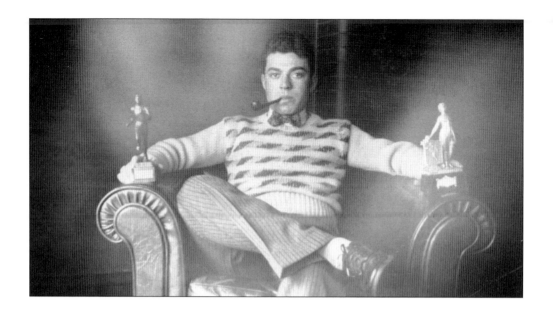

Above, Glasford, Illinois, native Patsey McElwee (class of 1930) proudly poses with a pair of trophies. McElwee was elected senior class president and junior class treasurer and was a member of Theta Nu Epsilon, Pi Gamma Mu (social science honors), Spanish Club, and college council. Below, Theta Upsilon member Lizzie Mary Shipley (far right) and her friends stand with the Pi Beta Phi sorority bungalow in the background. Shipley was a member of the French Club and Sigma Tau Delta, an honors society for English. (Both, Special Collections and Archives, Knox College Library.)

The Lombard College Orchestra was one of the last new organizations added, debuting for the 1928–1929 school year. The orchestra included violin, cornet, saxophone, trombone, bass, drums, and piano. In addition to performing for school plays, the orchestra performed a rendition of "Love Tales from Alsace Lorraine" by Lou Davis in a special chapel service. (Special Collections and Archives, Knox College Library.)

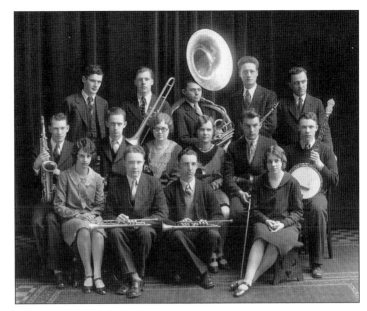

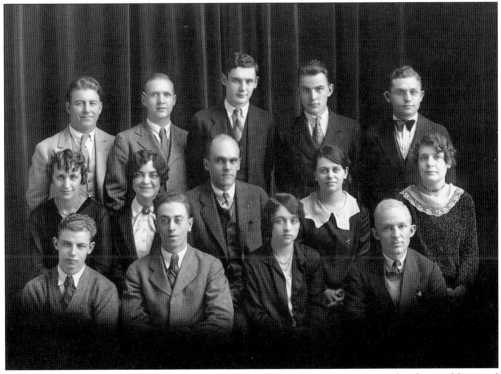

The 1928–1929 Glee Club had the honor of performing at commencement, school assemblies, and local recitals throughout the year. From left to right are (first row) Amos Emil Steinfeldt, Norton Becker, Lucile Tatman, and Chuck Morton; (second row) Ann Weinman, Harriette Glickson, professor Elbert Smith, Helen Davis, and Dorothy Puetz; (third row) Ernie Smith, ? McWilliams, Richard Pettis, Don Glenn Tornquist, and Ronald Mundweiler. (Special Collections and Archives, Knox College Library.)

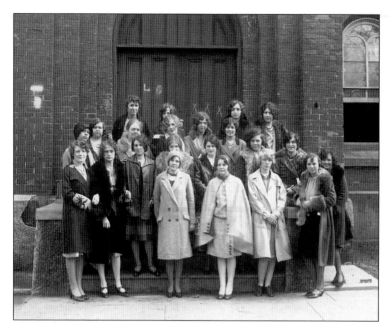

The Home Economics Club (pictured around 1929) was founded in 1919. Women who majored in home economics were encouraged to join to further help with their studies and continue their appreciation for the subject. This was one of the few clubs at the college designed solely for female students. (Special Collections and Archives, Knox College Library.)

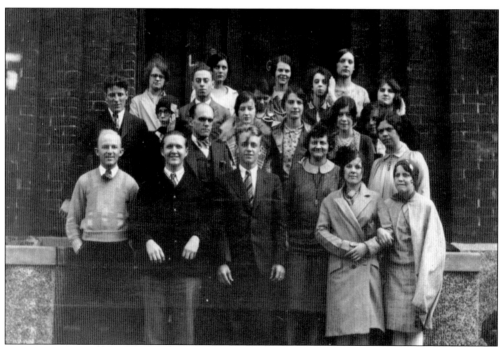

Bienvenue au Collège Lombard! That might be what one would hear if welcomed to Lombard College by the French Club. At the time of this 1929 photograph, French Club meetings were held twice a month. One meeting was business-oriented and held in the music studio, while the other was called French Tea and was held in the sorority bungalows. (Special Collections and Archives, Knox College Library.)

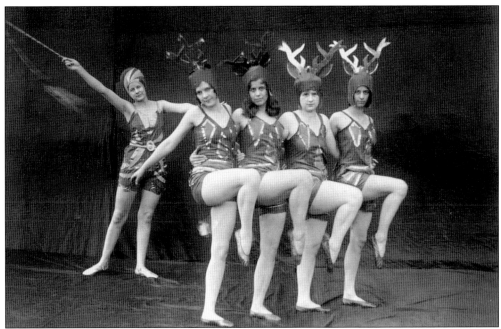

The Lombard Steppers Club was part of the women's athletic association and was established during the 1926–1927 school year. Membership was honorary and reserved for upperclassmen. The new club gave students the chance to create elaborate costumes and perform choreographed dances at pageants and commencement ceremonies. Designated themes were decided for each pageant, leaving the creativity to the students. The above photograph appears to show a pageant with a deer theme, as indicated by the antlers and ears. Below, two steppers show off their dance moves outside the western walls of Lombard Hall. (Above, Special Collections and Archives, Knox College Library; below, Galesburg Public Library Archives.)

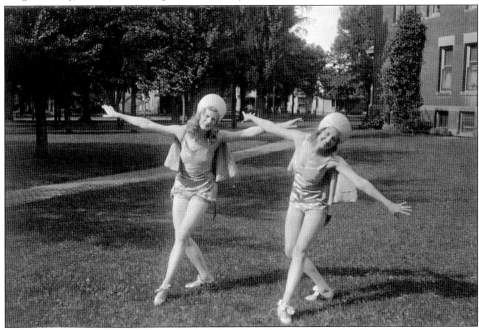

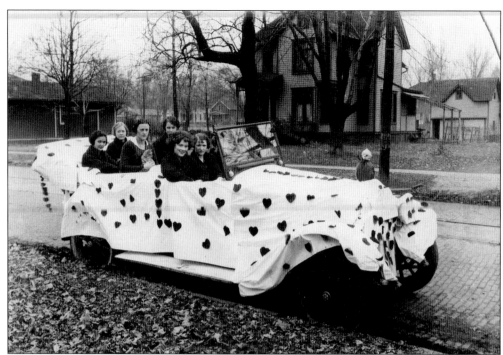

Homecoming was a time of pageantry that took place in late October or mid-November around an important football game. Leading up to the game, a parade was held, with the sororities designing floats. Both floats pictured here are from the Delta Zeta sorority. The car above has a sign attached to the front that reads, "Our hearts are with you Lombard." The 1925 homecoming dance was one of the more memorable in Lombard history. It was held in the gymnasium, which was decorated on the inside, and colored lights were wrapped around the outside towers. That year, the dance took place after a tough football loss—the first home loss in five seasons. In a nod to the resilience of Lombard fans, the male students still climbed the gym's towers to serenade the crowd in celebration. (Both, Special Collections and Archives, Knox College Library.)

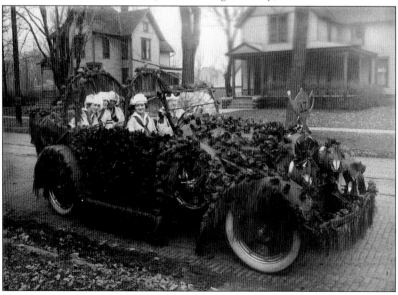

Four

THE OLIVE AND GOLD

Organized athletics at Lombard College can be traced to the creation of the athletic association, which hosted the first annual field day in 1888. The festivities were held the week of commencement and included the shot put, mile run, and 100-yard dash. Diligent records and times were kept at each event, setting the bar for future athletes. Crowds gathered to see the games, and the victors' names were published with pride in the local paper. The annual field day eventually gave way to the growing popularity of intercollegiate athletics. As athletic teams formed in baseball, basketball, football, and track, new school traditions emerged.

There was no bigger rival for Lombard than the crosstown Knox College. Football matchups between the two were referred to as the city championship game, which added a heightened importance. The tense rivalry included instances of Lombard students spying on Knox's football practice and a Knox professor accusing a Lombard player of being a professional athlete. All of the off-the-field controversies made for exciting matchups and some of the most well-attended athletic events in Lombard College history.

After Lombard College disappeared from Galesburg's landscape, one could imagine the chants of the college's fight song echoing through the remains of Lombard Field. As the students once sang, "Dear Old Lombard, bless her name, tis for her we fight for fame; Whether in defeat or victory and we'll shout her praises loud in every land, we are loyal just the same. Dear Old Lombard, bless her name."

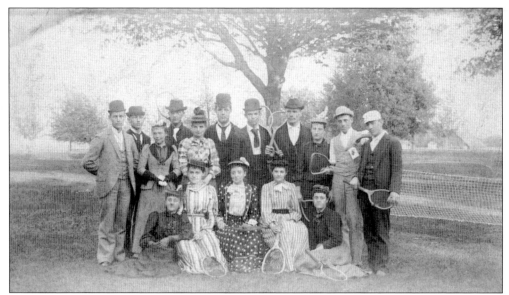

Well-dressed students pose on the tennis court with rackets in hand in June 1892. The original tennis courts were directly south of Old Main and nicknamed Love Hill. At the time, Lombard University's campus was wide open, with only trees in sight. Eventually, Lombard installed clay courts next to the football field on the southeastern side of campus. (Special Collections and Archives, Knox College Library.)

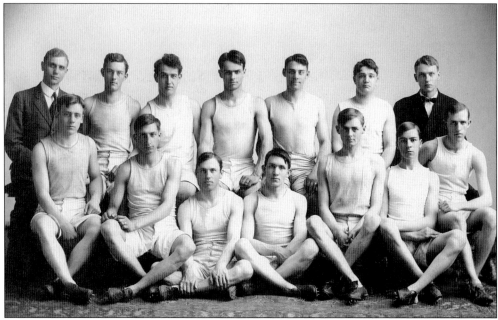

With the creation of team sports, athletic teams adopted the nickname the Olive and Gold, referencing the college's colors. Students who lettered in a major sport became members of the L Club—reserved for those who played a full season on a varsity team. The 1907 track team seen here was led by coach Orval Appleman (second row, far left). (Special Collections and Archives, Knox College Library.)

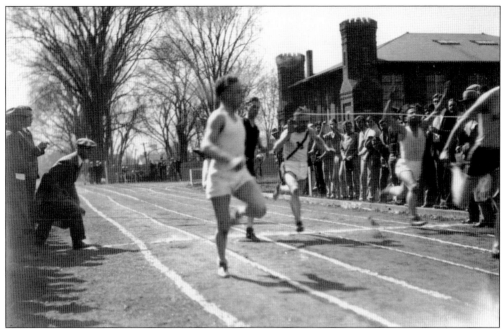

Above, runners race across the finish line as an exciting race comes to a conclusion. The Lombard College track was on the southeastern part of campus and outlined Lombard Field. The facilities were well regarded, as they hosted one of the largest high school track meets in the state, with over 300 competitors. Below, the 1921 track team is shown outside the windows of Tompkins Science Hall. From left to right are (first row) Sylvester Clayberg, Percy Yard, Howard Turner, Lester Hamblin (captain), George Hughes, Lorrence Rambo, Fred Rainey, and Evar Swanson; (second row) coach Carl Eggebrecht, Edward Flink, John Hess, Elder Meyers, Reuben Brockmueller, Jack Deets, and Ray Murphy. (Both, Special Collections and Archives, Knox College Library.)

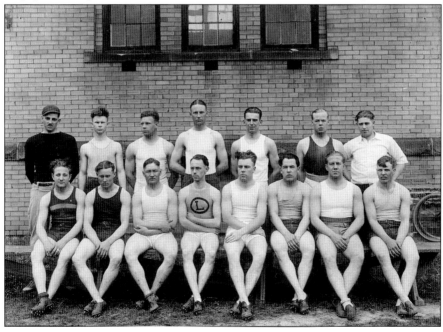

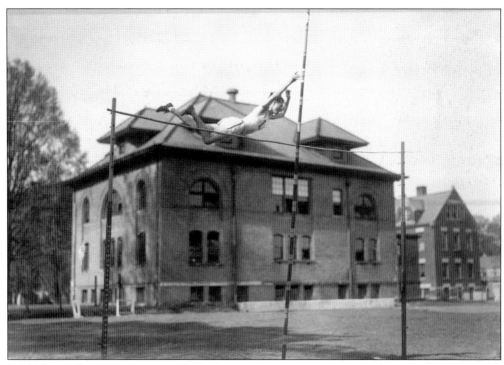

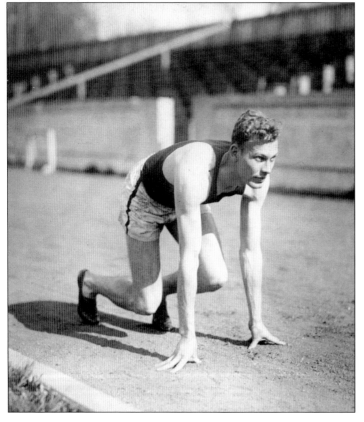

Above, Richard Johns attempts a pole vault proudly wearing the Lombard "L" across his chest. Tompkins Science Hall stands in the background, and Lombard Hall is behind it. Johns was a member of Sigma Nu and the class of 1931. At left, Arnold Draper (class of 1931) lines up on the Lombard Field track. He ran the 100-yard and 200-yard dash and was part of the mile relay team. With his success in track, Draper joined the L Club and became one of the best sprinters in the Little 19 Conference. Draper was also a member of Theta Nu Epsilon. (Both, Special Collections and Archives, Knox College Library.)

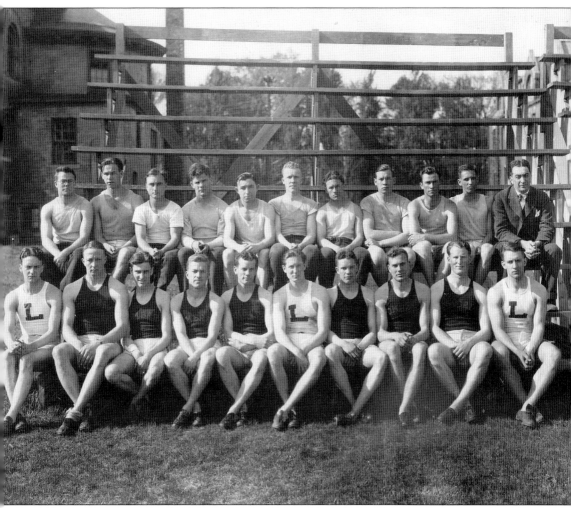

Senior and captain Harry Grubb (first row, far right) ran track during all four of his years at Lombard College and became a member of the L Club. He set the Little 19 Conference mile record with a time of 4:23.4 in a meet versus Bradley Polytechnic Institute. One of the highlights of his senior season was in the opening meet against Cornell College of Iowa, when he finished in first place out of 10 runners, running five miles in 28 minutes. Off the field, Grubb was a member of Theta Nu Epsilon, Spanish Club, and student council. The 1930 track team pictured here had several victories during that season, including over Loyola University of Chicago, Jacksonville College of Illinois, and YMCA College of Chicago. However, in the Little 19 Conference Meet, hosted by Knox College, Lombard came up short, finishing in second place behind Knox. (Special Collections and Archives, Knox College Library.)

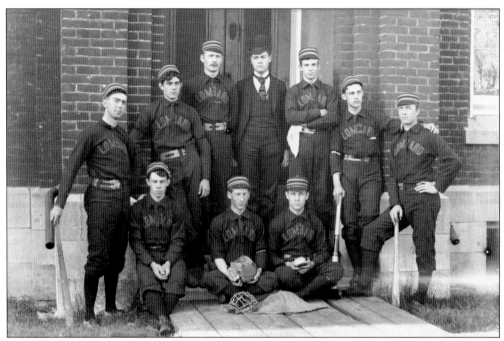

The 1892 Lombard University baseball team is pictured above with bats in hand on the steps of Old Main. One of Lombard's first recorded baseball games was a victory over Avon Club by a score of 3-1 in October 1894. Another memorable win from those days was a 19-1 home victory over Augustana College in April 1901. The baseball team did not have its own stadium for hosting games. Instead, the team shared Lombard Field with the football team. Baseball at Lombard was inconsistent in the early 1900s, with no guarantee that a team would be fielded each year. After a few years off, the 1909 team pictured below formed under coach Wayne Boyd and opened the season in Aledo, Illinois, against William and Vashti College. (Above, Galesburg Public Library Archives; below, Special Collections and Archives, Knox College Library.)

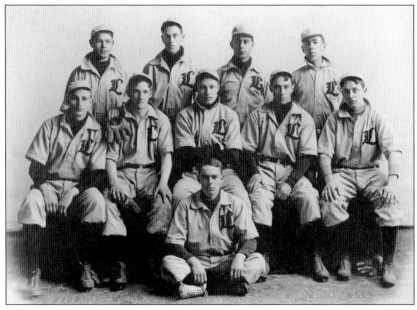

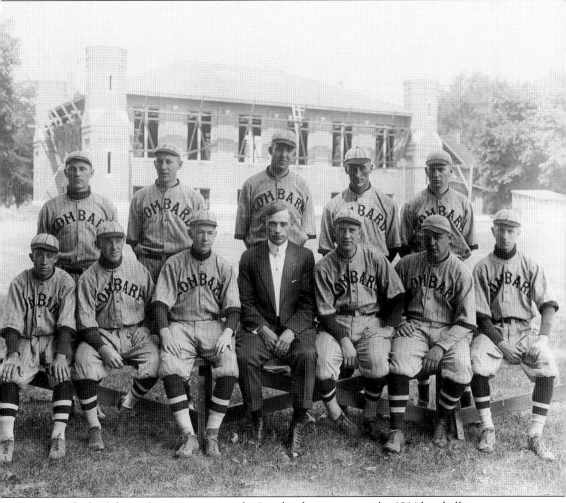

Against the backdrop of construction on the Lombard gymnasium, the 1914 baseball team poses for a group photograph. Led by coach Floyd Brown (first row, center), the team had victories over Eureka College, Arkansas University, and Northwestern College (now North Central College). Lombard also hosted a unique team called Chinese U, made up of Chinese players, who beat Lombard 7-0. One of the most controversial games of the 1914 season was against rival Knox College. Late in the game, Lombard scored on a close call at home plate, winning the game 5-4. The Knox team felt the runner never touched home plate and grew outraged at the call. The feud carried over to the newspapers, where both sides continued to fight. Ultimately, the colleges agreed to sever ties athletically when it came to scheduling future events. No Lombard-Knox football game was scheduled for 1915, although the matchup returned in 1916. (Special Collections and Archives, Knox College Library.)

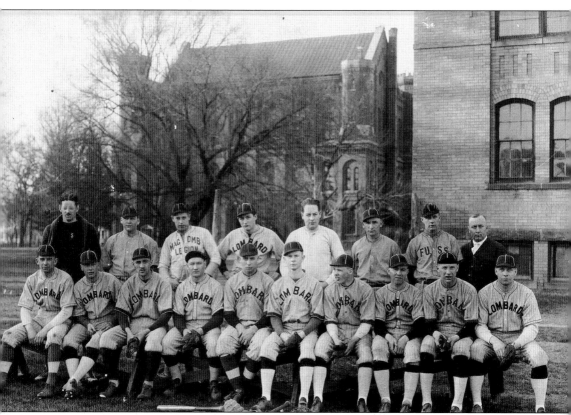

As in football, Lombard's baseball games against Knox College were eventually declared the city championship. The designation gave the games added importance, and they were played in a three-game series. The 1921 series was a fierce matchup for the two rivals; Lombard won the first game 2–1, while Knox fought back and won the second game 4–3. Large crowds gathered to see Knox win the third and deciding game 7–4. The 1921 team took their team photograph with Lombard Hall to the right and Old Main in the background. From left to right are (first row) Reuben Brockmueller, Beaumont Paine, George Mishey, Howard Turner, Gail Talbot, Edward Flink, Evar Swanson, Axel Miller, Elder Meyers, and John Hess; (second row) coach Carl Eggebrecht, Stuart Stephenson, Ray Murphy, Eugene Munson, Clarence Tipton, unidentified, Robert Hannum, and unidentified. (Special Collections and Archives, Knox College Library.)

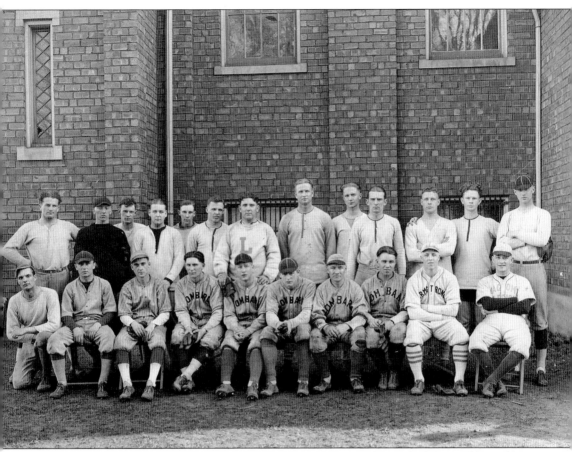

In 1922, during his sophomore year, Evar Swanson (second row, sixth from left) asserted himself as the star of the baseball team. He earned the nickname the "Lombard Flash" for his speed around the bases—his record time of 13.3 seconds has never been beaten. Swanson became Lombard's first and only player to make it to the Major Leagues, playing for both the Cincinnati Reds and Chicago White Sox. At Lombard, Swanson helped lead the 1922 team to a surprising 13–7 victory over the Moline Plowboys, a professional minor-league team. Pictured here are, from left to right, (first row) Leonard Ott, Lauren Goff, W. Blake, Russ Trimble, Beaumont Paine (captain), Eugene Munson, Howard Turner, Axel Miller, Roy Lamb, and Frank Nestor; (second row) Cecil King, ? Warner, William Watson, Robert Stephenson, Wesley Briggs, Swanson, George Kasper, Tommy Thompson, James Rogers, Reuben Brockmueller, John Hess, Edward Flink, and Elder Meyers. (Special Collections and Archives, Knox College Library.)

Carl Sandburg (first row, first on the left) was not only talented with a pen but also with a basketball. He played all four years while attending Lombard College and even captained the championship 1901–1902 team. Sandburg tried baseball and football, too, but found a love for basketball, remarking that it was the only sport he never thought about quitting. (Rare Book & Manuscript Library, University of Illinois at Urbana-Champaign.)

This image of the 1900–1901 basketball team features Sandburg sitting front and center holding the ball. He had one of his greatest athletic moments during this season. In a game versus the Burlington Athletic Association, Sandburg hit a last-second shot from under the basket to win the game 12–10 for Lombard. (Galesburg Public Library Archives.)

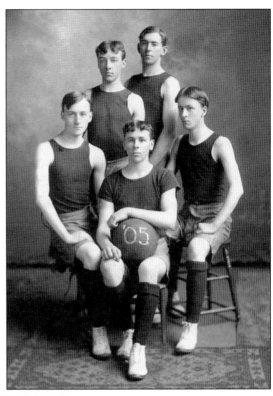

In 1905, Lombard faced tougher collegiate opponents. An undefeated Augustana College beat Lombard twice, allowing Augustana to make a claim for the state basketball title. Ray Justus, the tallest player, stands in the back of the 1905 team photograph at right. Justus was a dual-sport athlete, also starring on the football team. The 1906 team below sports a more modern jersey. From left to right are (first row) Ralph Atterbury; (second row) Ernest Oberholtzer, Ray Justus (captain), and Walter Hughes; (third row) Ernest Linderholm and LeRoy Robinson. (Both, Special Collections and Archives, Knox College Library.)

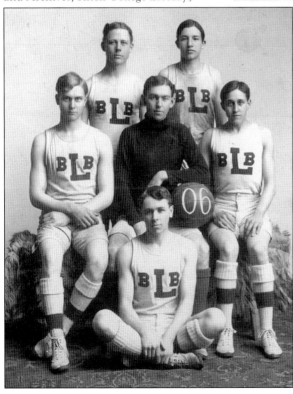

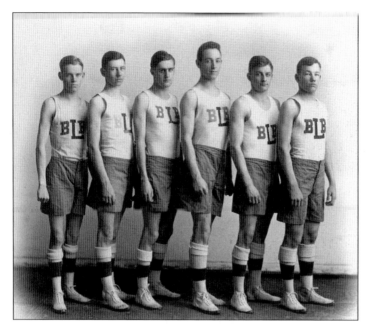

The 1911 team claimed a big victory over Illinois State Normal University, winning 48–25 on February 24, 1911. Until this point, Lombard had played all basketball games in Alumni Gymnasium before transitioning to the new Lombard gymnasium in 1915. One of the last games in the old gym was a dominant 63–13 victory over St. Ambrose University on February 4, 1914. (Special Collections and Archives, Knox College Library.)

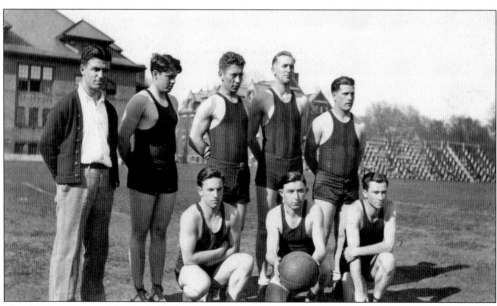

The 1930 intramural basketball champions known as the Barbs are shown posing on Lombard Field. On their way to the tournament title, the Barbs defeated Sigma Nu, Pi Kappa Alpha, and Theta Nu Epsilon. The college offered a wide variety of intramural athletics to students, including tennis, golf, and track. (Special Collections and Archives, Knox College Library.)

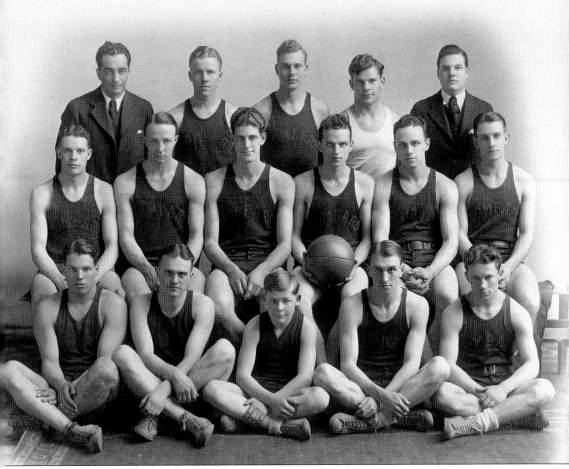

Coach Harry Bell (third row, far left) led the 1928–1929 Lombard basketball team to a Little 19 Conference title. The title chase was supported by the strong play of senior and captain Francis Hall (second row, holding ball). Early losses to the University of Illinois and University of Wisconsin did not discourage the team. Impressive performances over conference opponents Western Illinois State Teachers College, Shurtleff College, and McKendree College boosted the team to the top of the conference. In the final game of the season, held at the Galesburg Armory, Bradley Polytechnic Institute was leading 35–32 late in the game. Hall was able to score a basket, pulling Lombard to within one point. The ball fell back into Lombard's hands, with the team still trailing by only one point. Hall had the ball again, this time passing to his big man, Ellis Nickolaus, who hit the game-winning shot, giving Lombard a 36–35 victory and the conference title. (Galesburg Public Library Archives.)

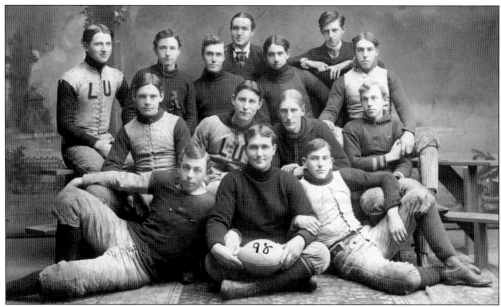

Around the turn of the 20th century, the first Lombard University football matchups were held against local athletic clubs. In November 1898, Lombard lost to Streator Athletic Club 22–0. In this era, it was not uncommon for such clubs to outclass college teams. Lombard fared better against collegiate opponents, with wins over Bradley Polytechnic Institute, Iowa Wesleyan College, and Monmouth College. The 1897 team is pictured here. (Special Collections and Archives, Knox College Library.)

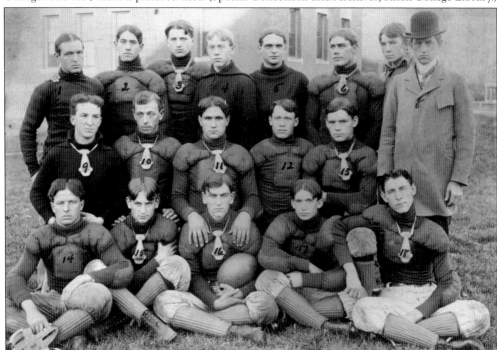

Carl Sandburg snuck into the 1899 football team photograph, second from right in the third row. Unlike basketball, Sandburg realized after a couple of hard hits in practice that football was not the sport for him. (Rare Book & Manuscript Library, University of Illinois at Urbana-Champaign.)

The 1902 football team faced their first collegiate opponent of the season, the University of Chicago, on September 20, 1902. Chicago shut out Lombard the previous year under the instructions of Chicago captain James Sheldon, who remarked, "Beat Lombard, from start to finish. Never let them score." However, in this game, Lombard player Harry Jansen broke a tackle to score in the 27–6 loss. (Special Collections and Archives, Knox College Library.)

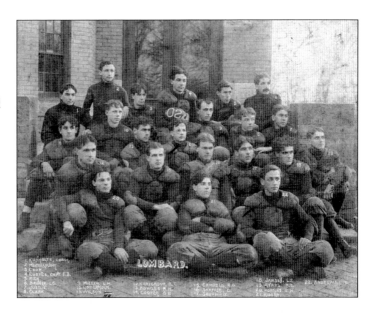

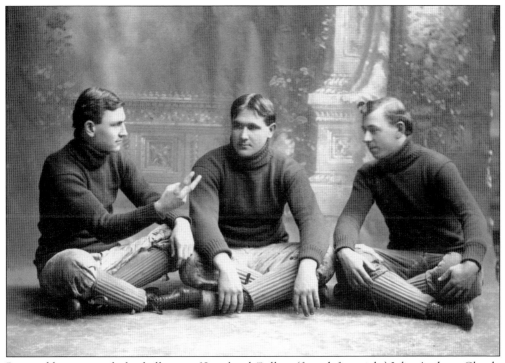

Pictured here are early football stars of Lombard College (from left to right) John Andrew, Claude Hartgrove, and Ralph Miller. Hartgrove was a force on the defensive line and doubled as the team's kicker. His temper got the best of him in a 1902 game versus Monmouth College in which he apparently assaulted the referee. (Special Collections and Archives, Knox College Library.)

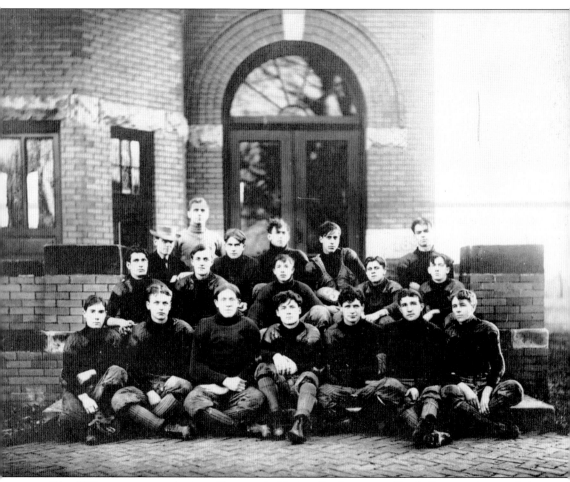

The 1905 team was overshadowed by tragedy. Nationally, the game of football was under attack due to safety concerns, which Lombard College witnessed firsthand. In a contest against the Peoria Social Athletic Club, Peoria player George Prior suffered an injury that left him permanently disabled. As a result of the gruesome injury, President Fisher banned football. He remarked, "The colleges have gone football mad. The roar over a football game reaches to heaven, while listen as you may, you cannot catch a whisper of what is going on in the college classroom. Lombard College stands for a great and serious business." Lombard students proceeded to cremate a football in protest of the decision. Their protest was unsuccessful, and no football team was organized for the 1906 season. To the students' relief, football returned to Lombard in 1907. (Special Collections and Archives, Knox College Library.)

Star center Ray Justus was one of the players affected by Lombard's ban on football in the 1906 season. He missed his junior season because of the ban but returned in 1907 for his senior year. Perhaps his biggest game came at Lombard Field against Illinois Wesleyan University on September 23, 1905. Justus scored two touchdowns, leading Lombard to a 15-0 victory. (Special Collections and Archives, Knox College Library.)

Throughout its history, Lombard College had many great triumphs on the football field, but 1909 was not a strong season for the Olive and Gold. On November 6, Lombard surrendered 70 points in a defeat to Lake Forest College. In the loss, Lake Forest claimed the title of Middle-West champions. The result would stand as the most points ever surrendered by Lombard in a single game. (Special Collections and Archives, Knox College Library.)

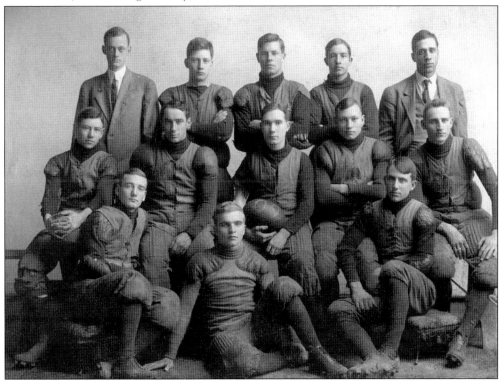

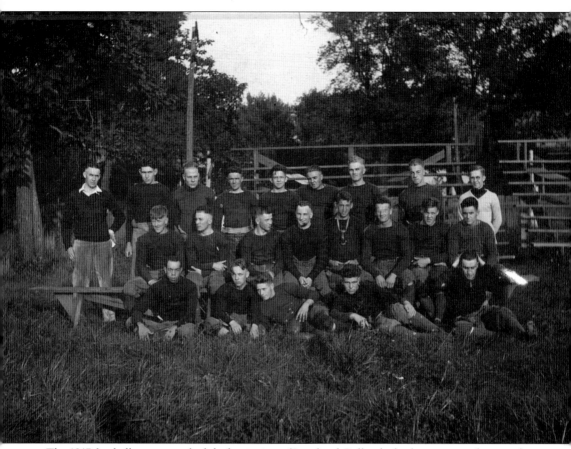

The 1917 football season marked the beginning of Lombard College's climb to perennial contenders. Lombard hosted Bradley Polytechnic Institute on November 17, 1917, with a chance to secure their first Little 19 Conference title. The opening kickoff was received by Lombard, which started the game with a five-minute drive that resulted in a touchdown. From that point on, the heroic passing skills of quarterback Donald Peden led Lombard to a 49–0 victory. The win solidified Lombard as the 1917 Little 19 Conference champions. While there was much to celebrate, Lombard had one more game left on the schedule—crosstown rivals Knox College, on November 23, 1917. The conference champions failed to beat Knox, losing 9–3 and leaving Lombard still searching for a perfect season. (Galesburg Public Library Archives.)

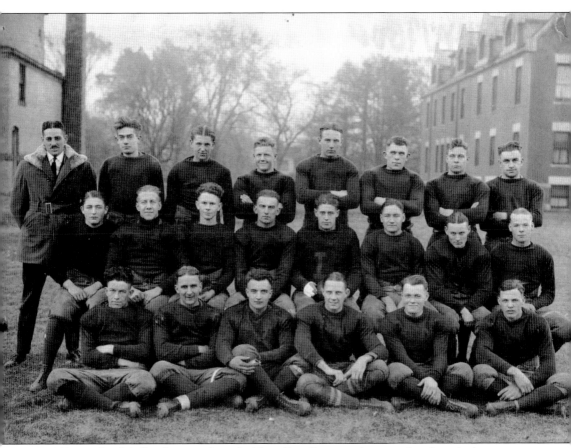

In 1920, Lombard College's most talented athlete, Evar Swanson, became a breakout freshman star. An injury to a starter allowed Swanson to get on the field and prove himself against Monmouth College. He did just that, scoring two touchdowns in a 17–0 Lombard victory. An early October 20–3 loss to Augustana College prevented a second conference title. The football program was building toward something special, though, as the team finished that season with a 7–1 record and a talented freshman class. Pictured here are, from left to right, (first row) Clifton Adams, George Olson, Edgar Foedisch, Robert Hannum, F. Rosequist, and Swanson; (second row) Eugene Munson, Fred Rainey, Edward Flink, Reuben Brockmueller, Ray Murphy (captain), Howard Turner, Percy Yard, and Jack Deets; (third row) coach Carl Eggebrecht, R. Snow, Lester Anderson, Ken Smith, M. Meyers, Delbert Faulkner, John Hess, and Russ Anderson. (Special Collections and Archives, Knox College Library.)

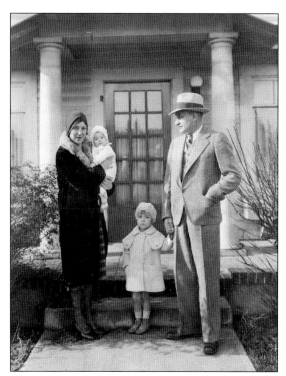

As the 1920 offseason unfolded, Lombard College needed a new football coach. The final part of making Lombard a powerhouse was the hiring of coach Paul Schissler, a University of Nebraska assistant coach pictured with his family. Schissler brought with him several talented Nebraska players, including quarterback Roy Lamb. (Harriet's Photograph Collection, Oregon State University Special Collections and Archives Research Center.)

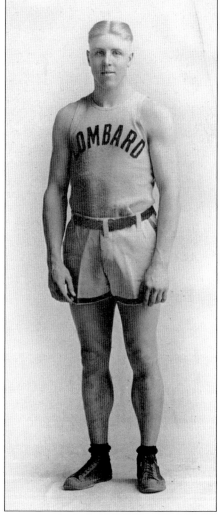

Star quarterback Roy Lamb, who played from 1921 to 1924, could pass, throw, run, and kick. Impressively, in a 1924 game against Mount Morris College, Lamb scored 52 points himself. His talent led him to National Football League stints with the Rock Island Independents and Chicago Cardinals. Lombard College boosters awarded Lamb—along with other standouts—a gold watch engraved with an L. (Special Collections and Archives, Knox College Library.)

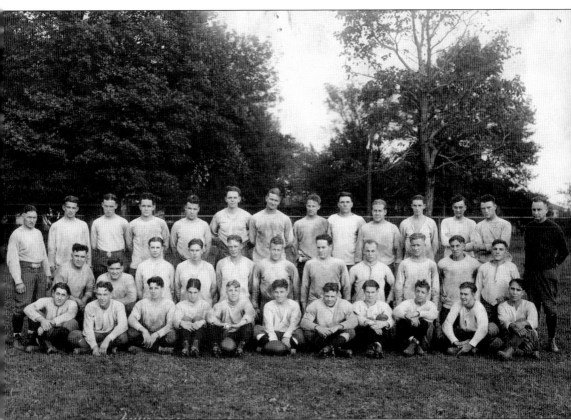

The 1921 football season culminated in a rain-soaked 14–0 victory over Knox College, which forced a one-game conference title match versus St. Viator College. In the title game's opening minutes, Roy Lamb rushed for a touchdown. Lombard College never looked back, winning 27–7. For the 1922 season, coach Paul Schissler looked to build upon his success by adding more challenging out-of-state opponents, which led to Lombard defeating both Ripon College and Kalamazoo College. One of the few blemishes of the 1922 season was a tie against the University of Detroit. Lombard impressed many fans with the 6–6 tie, considering Detroit were large favorites in the game. Once again, Lombard faced off against St. Viator College for the conference title match, winning 20–6. Both the 1921 and 1922 teams (pictured) went undefeated, claiming two conference titles and outscoring their opponents 586–49. (Special Collections and Archives, Knox College Library.)

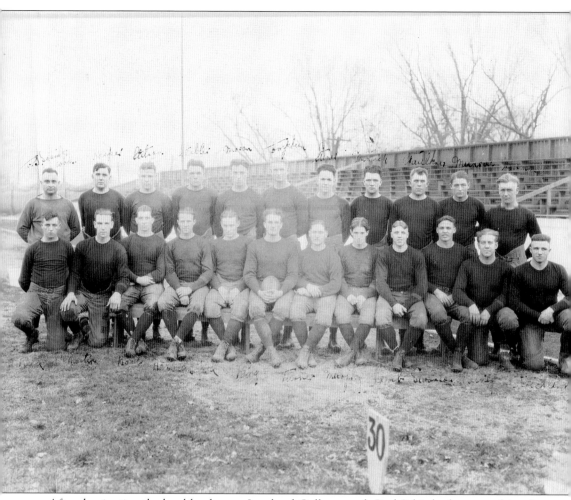

After dominating the local landscape, Lombard College coach Paul Schissler kept searching for better opponents to play his 1923 team (pictured). Coach Schissler got his wish on October 6, 1923, when Lombard traveled to South Bend, Indiana, to play one of the best teams in all of football—the University of Notre Dame. The hard-fought game ended in an impressive 14–0 loss for Lombard. Even in defeat, the close game was viewed as a victory for such a small school. The loss did not stop Lombard from winning out the rest of the season, which they finished with a 6–1 record. To top off a great season, Lombard defeated Knox College for the fourth straight year by a score of 20–0, with Roy Lamb scoring three touchdowns. With the closing of the 1923 season, Evar Swanson graduated, earning a school record of 16 letters in his college career. (Special Collections and Archives, Knox College Library.)

As seen at right, legendary University of Notre Dame coach Knute Rockne (left) and Lombard College coach Paul Schissler became friends off the football field. The close game between their schools in 1923 impressed Rockne enough that he scheduled matches with Lombard for 1925 and 1926. Unfortunately for Lombard, Schissler was no longer coach for those matchups. After Schissler led Lombard to a 22-1-2 record, outscoring opponents 816–76 and winning three straight conference titles, he accepted a head coach job with Oregon Agricultural College. Schissler (at center below) eventually brought Roy Lamb (left) on as an assistant coach. Later in his career, Schissler became one of the founders of the National Football League's Pro Bowl. (Both, Harriet's Photograph Collection, Oregon State University Special Collections and Archives Research Center.)

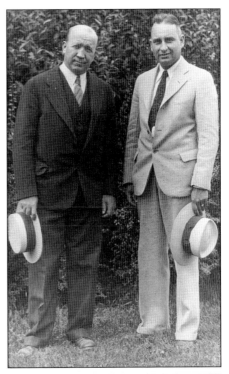

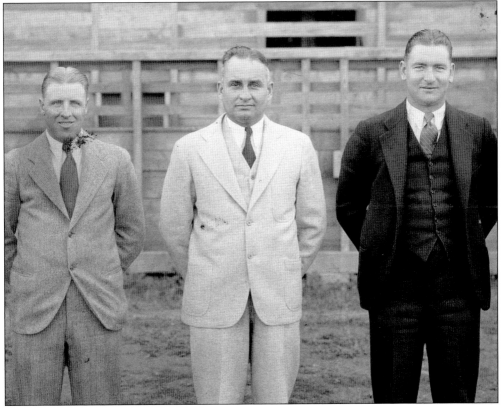

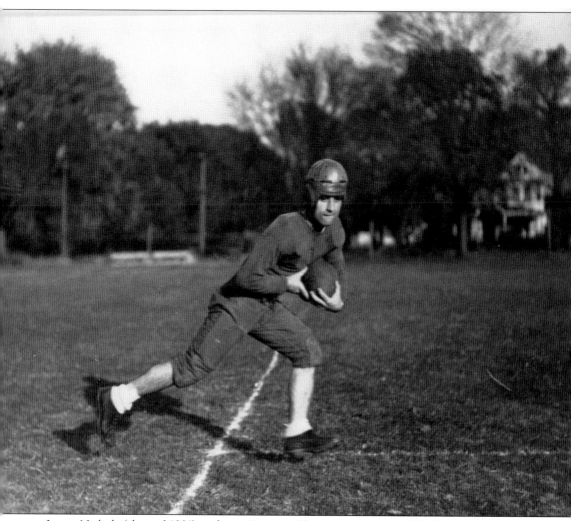

Lewis Nichols (class of 1931) strikes a Heisman-like pose on Lombard Field. After coach Paul Schissler left, Lombard College still had a good football program, but not to the extent it had previously reached. Harry Bell stepped in as coach from 1924 to 1930, becoming the last head coach in college history. He was a graduate of Drake University and had previously coached at Des Moines University from 1920 to 1923. In 1924 and 1929, Lombard won two more conference titles, sharing both claims with Knox College. During the 1929 season, the football program had an impressive 6-1-1 record. The last Lombard football game ended with a 7-7 tie against the University of New Mexico. The team began preparing for the fall of 1930, scheduling matchups against DePaul University and defending Big Ten champions Purdue University, but as a result of Lombard's impending closure, the games were never played. (Special Collections and Archives, Knox College Library.)

Five

THE LEGACY OF LOMBARD COLLEGE

After Lombard College closed, the Galesburg Board of Education purchased the campus for $75,000 in January 1931. The intention was to use the existing Lombard College buildings to establish Lombard Junior High School. Old Main served the role well and helped relieve congestion in the Galesburg public schools. Numerous alumni events and the development of the former campus continued to keep the public interested over the years.

Beyond Lombard's physical landmarks, the college's legacy lives on within the community. Directly north of Knox College's campus is Standish Park, which pays tribute to Dr. John Van Ness Standish, who had a well-known love of horticulture and served as president of the Galesburg parks board. Weston Elementary School, at 850 Mulberry Street, was named after Lombard College's former president Dr. James Partelow Weston. At the Carl Sandburg Historic Site, tributes and artifacts relating to Lombard College are displayed, recounting Sandburg's college years. Knox College awards the Philip Green Wright–Lombard College prize to outstanding professors and maintains the Knox-Lombard Athletic Hall of Fame.

It was Rev. Charles West who reflected on Lombard University's humble beginnings at commencement in 1860, stating, "May we never forget the day of small things." Through the efforts of Lombard alumni, professors, and community members, the small but important things that made up Lombard College can still be found in Galesburg today.

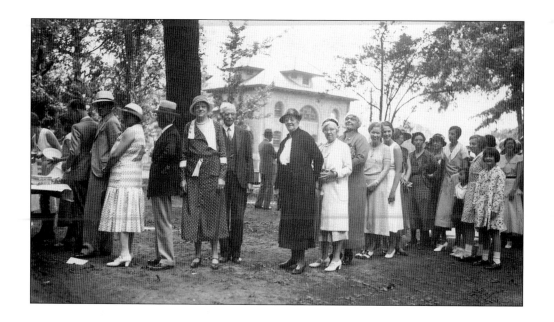

A Lombard College reunion picnic held on June 9, 1932, is shown in both photographs. Anyone affiliated with Lombard—alumni, former faculty, and descendants of Lombard graduates—was welcome at the annual picnic. The reunion tradition predated the demise of Lombard; it was started in the early 1900s and continued for several years after the college closed. Above, hungry picnickers wait in line for a buffet, with Tompkins Science Hall in the background. Below, a group of Lombard College women gather in front of the ivy brick walls of Old Main. (Both, Special Collections and Archives, Knox College Library.)

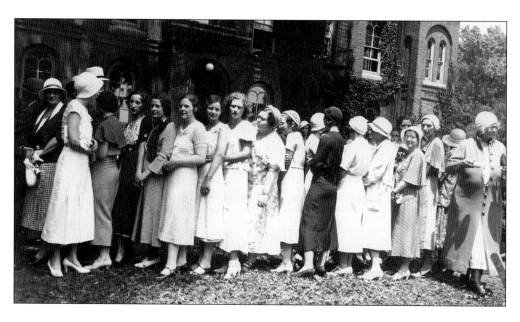

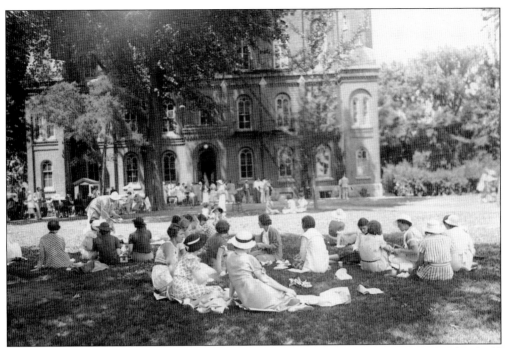

Above is another look at the 1932 reunion picnic. The picnics were held on the south side of Old Main under the shade of the campus's many trees. Guests can be seen exiting the opened door of the "old spoon holder" from Old Main. No drastic changes were made to campus immediately after the sale of the property. Below, participants at the 1934 reunion picnic once again gather outside Old Main. Alumni brought their whole family to spend the day on their alma mater's campus to reminisce and reconnect with friends. (Both, Special Collections and Archives, Knox College Library.)

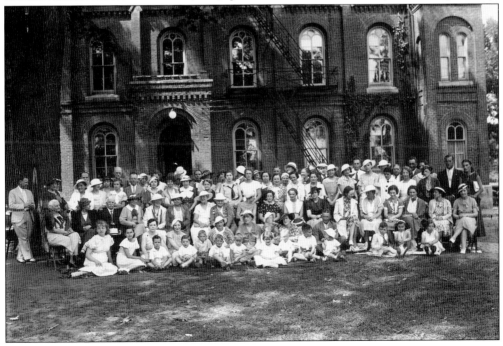

As time went on, Knox College continued to foster and preserve the legacy of Lombard College. On October 24, 1936, the Lombard College bell was dedicated near Knox College's Old Main. The newly constructed memorial was paid for by Lombard College alumni and designed to resemble the Gothic towers of Lombard's Old Main. (Galesburg Public Library Archives.)

Throughout the college's later years, Lombard catalogs advertised that alumni were encouraged to visit as often as possible. The college treated alumni as an active part of the student body and a key part of the college community. The value placed on the alumni shows in the attendance at the 1936 reunion picnic seen here. (Special Collections and Archives, Knox College Library.)

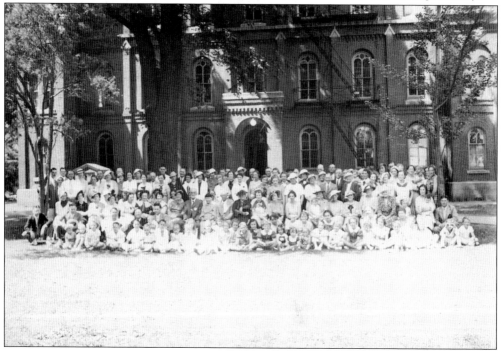

Alumni of all ages attended the reunion picnics, even those who had graduated in the 19th century. At right, Lloyd Jones (class of 1883) shows his spryness during the 1936 picnic. Jones graduated with a bachelor of science degree and later worked as a county surveyor. In 1937, some alumni events began to merge with those of Knox College, as seen below. The joint venture further unified the alumni of each school, especially for those who ended up attending Knox after Lombard's closure. The below photograph was most likely taken on the Knox College campus. (Both, Special Collections and Archives, Knox College Library.)

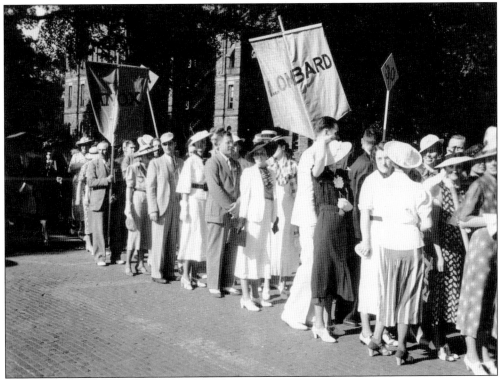

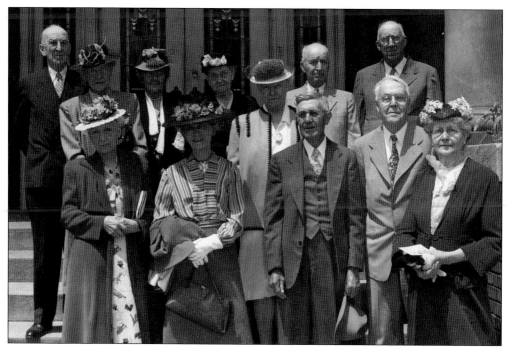

A Lombard College reunion is pictured above on the steps of the Galesburg Club in June 1947. Headlining the event were several alumni from the 1890s. Visiting alumni included Loetta Boyd, Nina Alta Harris, Theodore Lindquist, Benjamin Downs, Jay Bullman, and Alice Bartlett. The group attended services at the Galesburg Universalist church and enjoyed a sermon performed by alumnus Edward Minor. The event was capped with a dinner at the Galesburg Club and a tour of the former campus. Below, the 1938 picnic took place in its usual location with many alumni attending; however, this would mark the beginning of changes to the Lombard campus. (Both, Special Collections and Archives, Knox College Library.)

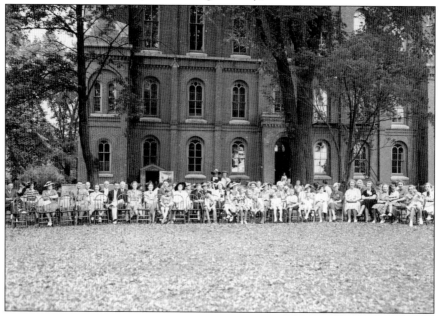

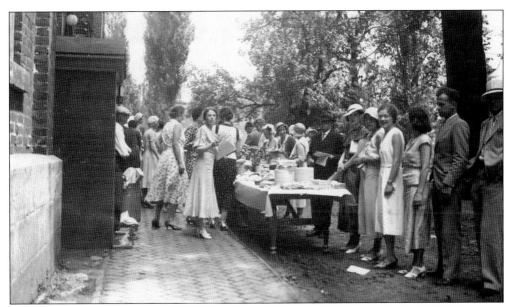

These photographs provide an interesting contrast with Lombard College's former campus. Above, during the 1932 picnic, the brick walls of Old Main are to the left, and in the distance to the east, the bricks of Lombard Hall are faintly visible. By the time of the 1938 picnic below, the Galesburg Board of Education had determined that Old Main was outdated and no longer suitable for classes. It was decided that Lombard Hall would be demolished in 1938, allowing Lombard Junior High School to abandon Old Main and construct a new building. The loss of Lombard Hall was the first major alteration to campus since Lombard's closure. (Both, Special Collections and Archives, Knox College Library.)

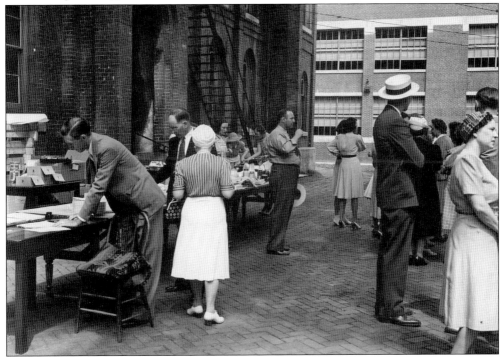

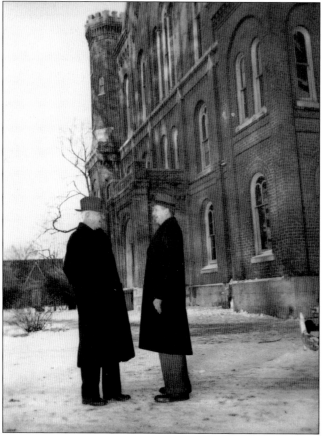

This undated photograph gives a glimpse into the new layout of Lombard College's campus after the new Lombard Junior High School building was completed in 1939. The picture was taken looking north toward Old Main with the new school building to the east. (Special Collections and Archives, Knox College Library.)

In 1948, Carl Sandburg (left) returned to campus. He reminisced about his college days, guided by Knox College president Lyndon Brown (right). Galesburg's native son had returned to celebrate his 70th birthday with friends and deliver a lecture at Knox College. (Special Collections and Archives, Knox College Library.)

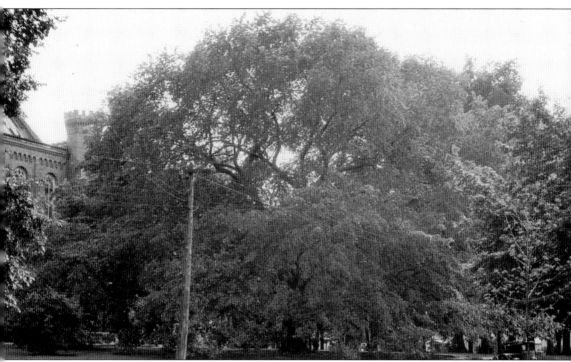

After Lombard College closed, the Lombard elm continued to grow and was maintained by local School District 205. Early on, Dr. John Van Ness Standish warned that planting too many elm trees was a risky decision based on their tendency to catch diseases. It took almost 100 years for his hypothesis to be proven true. In 1963, the tree succumbed to Dutch elm disease, losing all its leaves and withering away. Bark beetles were responsible for transmitting the disease from tree to tree. The school district knew the importance of the tree and took extra care in verifying that it was terminally ill. University of Illinois floriculturists confirmed the diagnosis, and the Lombard elm was chopped down in August 1966, leaving the campus without its second-oldest landmark. (Galesburg Public Library Archives.)

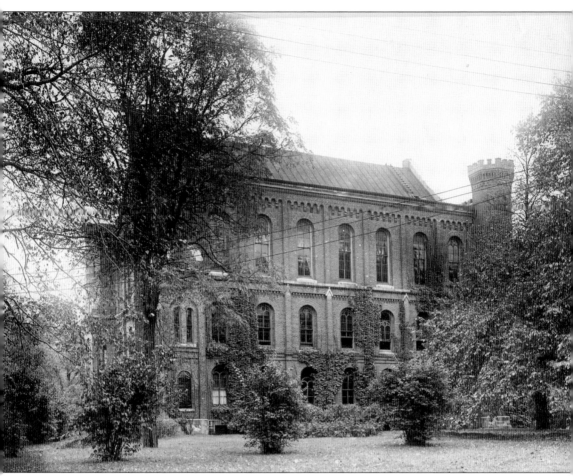

The 1940s were not kind to Old Main, as the war effort dampened any fundraising for the building's preservation. Old Main had a constant issue of vandals breaking its windows. The focal point of Lombard College had become abandoned and routinely vandalized. Note the black bag covering a broken window at lower left. After the junior high school building was constructed, the Galesburg Board of Education had little use for Old Main. The local parent teacher association became concerned with student safety as falling bricks from the crumbling old structure posed a hazard to children. When the structural integrity of the building was assessed, it was determined that Old Main's only current use was storing athletic equipment. (Galesburg Public Library Archives.)

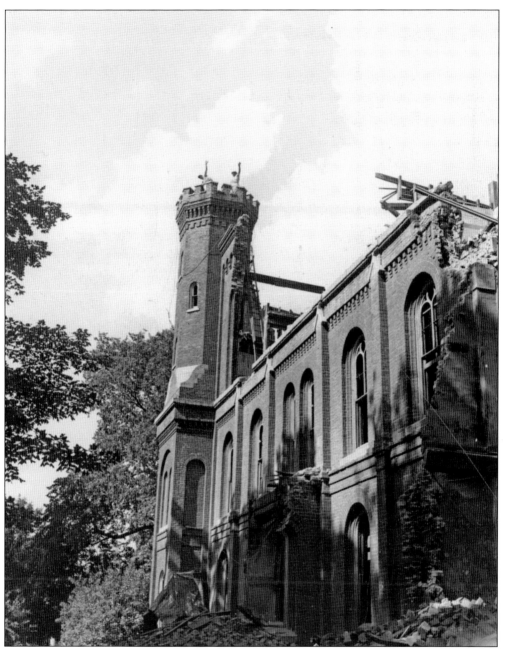

In 1954, a vote was held approving the sale of Old Main to a wrecking company for demolition. The referendum resulted in a vote of 860 to 803 in favor of demolition. Ted Hall Wrecking, from Des Moines, Iowa, was awarded the demolition contract for $1,890. Lombard College alumnus Dr. Quincy Wright, son of professor Philip Green Wright, pushed for the preservation of Old Main. Wright argued that since the vote was so close, more time and thought should be given to the matter. However, the decision was made final, and in July 1955, the demolition of Old Main officially commenced. The roof was the first part of the structure to go, then the building was taken apart floor by floor. Ropes were tied to the walls and attached to a truck, which ripped out the bricks. (Galesburg Public Library Archives.)

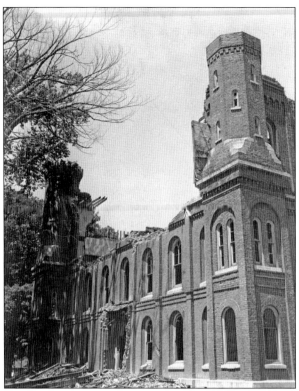

Old Main had its defenders, who believed that the building could have been saved. Ideas for repurposing included restoring the building as a museum or a community center. One of the most unique proposals was taking the bricks and building a one-story replica in tribute. None of the ideas gained enough traction to be acted upon. The loss of Old Main became the second-biggest loss for Lombard College preservationists after the demolition of Lombard Hall. Losing the college's biggest landmark hurt many alumni, as Old Main's importance was often the theme of many old Lombard songs—"In memory Lombard's turrets rise, above the elms pointing to the skies, stronger, truer men we'd be, O Lombard, when we think of thee." (Both, Galesburg Public Library Archives.)

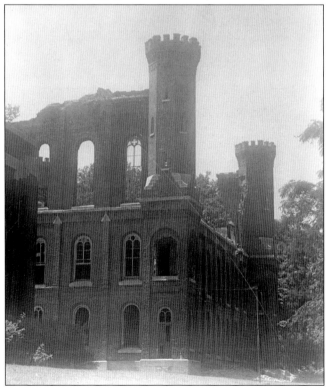

As Lombard College's physical footprint shrank, the alumni persisted. The college's legacy continued through reunions and the alumni's shared memories of their alma mater. Alumni began being welcomed back three times a year—for a Founder's Day celebration in February, commencement in June, and homecoming in October. A 1971 reunion (pictured above) brought together alumni (from left to right) Richard Peasley, Murray Smith, Roy Lamb, Gil Martin, and Reuben Brockmueller. The reunion took place in the Carl Sandburg Lounge on Knox College's campus. The former stars of the Lombard College football team pictured below are, from left to right, (first row) Noel Mosher, Lamb, Earl Murphy, and Cecil King; (second row) Herman Allen, Evar Swanson, Brockmueller, and Martin. (Both, Special Collections and Archives, Knox College Library.)

Pictured above from left to right are three members of the class of 1928: Marion Venell, Violet Field, and Mabelle Moore (Knox alumna). While at Lombard, Venell was a member of Pi Beta Phi and participated in basketball and track. Field was a member of Delta Zeta. Below, Alice Simmons-Cox from the class of 1925 is seated at left. She was extremely involved in campus life, serving as president of Lombard Hall, secretary of the junior class, and a member of Pi Beta Phi. After college, she moved to Peoria, where she began writing and publishing works for the Baha'i faith. (Both, Special Collections and Archives, Knox College Library.)

From left to right are Lombard College alumni Hortense Gehring and Dorothy Spoerl, and Knox College alumnus Eleanor Sennk. Spoerl was the daughter of former Lombard College president Dr. Joseph Tilden. She graduated from Lombard in 1927 during her father's presidency. Her degree led her to a long career as a minister in the Universalist Church from 1929 to 1973. (Special Collections and Archives, Knox College Library.)

Two Lombard College Sigma Nu members are seated next to each other at a reunion—Lawrence Brennan (left, class of 1929) and Frank Whiteside (class of 1927). Whiteside was a member of the L Club for his contributions to the track team. Brennan was president of his junior class and captained three football games in 1928. (Special Collections and Archives, Knox College Library.)

Hortense Gehring (right) was known for her speaking ability, taking first place in the 1924 Townsend Prize Contest. The Galesburg native graduated in 1927 and was a member of Pi Beta Phi and the Spanish Club. During her senior year, she played the role of Dora in the class play *Enter Dora, Exit Dad*. (Special Collections and Archives, Knox College Library.)

George Hansman (class of 1927) and his wife, Helen, are pictured at a Lombard College reunion. Hansman was a member of Sigma Nu and played basketball for three years. During his senior year, he was named captain of the team. He led Lombard to an impressive 25–24 home victory over one of the top teams in the country, Butler University. (Special Collections and Archives, Knox College Library.)

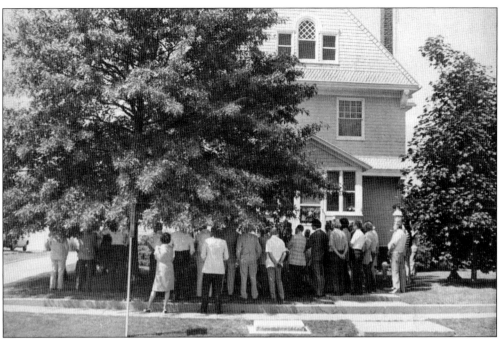

Lombard College received a mention on a historical marker on June 9, 1978. Prof. Philip Green Wright's former home was given the honor due to his printing of Carl Sandburg's first published works in the house's basement. Longtime Knox College professor Hermann Muelder spoke at the dedication ceremony, detailing Wright's relationship with Sandburg. Members of the Wright family and Lombard College alumni attended the event. From left to right are John Baily, Theodore Wright, Sewell Wright, Hermann Muelder, Gail Youngren, and Henry Wright (in front). The home still stands at 1443 East Knox Street and is now a private residence. (Both, Special Collections and Archives, Knox College Library.)

Several Lombard College buildings found a second life under the use of the junior high school. Tompkins Science Hall was used as extra classroom space, Lombard gymnasium held physical education classes, and the sorority bungalows were used for special education. However, by the late 1970s, Tompkins Science Hall and the gymnasium began to show their age. In 1977, safety hazards became an issue in Tompkins, causing the school to move classes to the bungalows. Repairs would be costly, and there was not enough money to repair both buildings. Tompkins Science Hall was connected to the main school building through an annex, so there would be no redevelopment ideas or refurbishment plans outside of it being used for classrooms. The hall survived for several more years, operating in a reduced capacity as a teachers' lounge and storage space. (Special Collections and Archives, Knox College Library.)

By July 1990, demolition had begun on Tompkins Science Hall. After a month of removing asbestos, the once-grand gymnasium that gave Carl Sandburg the opportunity to play basketball was razed. Permission was granted to alumni to save the cornerstone. The 1897 cornerstone is now located on the Knox College campus. (Special Collections and Archives, Knox College Library.)

At the corner of East Knox and Lombard Streets, the diagonal walk to Old Main no longer exists. However, the brick sidewalk from Lombard College's time still exists, looking east down East Knox Street. It is the same sidewalk that was used on campus and that can be seen in several of the photographs in this book. (Author's collection.)

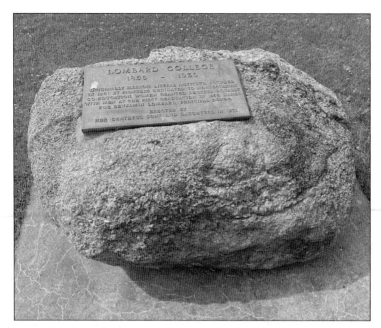

In 1972, Lombard College received an official historical marker. A boulder was placed on the campus of Lombard Junior High School with a plaque briefly detailing the college's history. Alumnus Evar Swanson was on hand to speak and dedicate the marker. In 2014, Lombard Junior High became Lombard Middle School. The marker can still be seen today to the west of the school's entrance. (Author's collection.)

Outside Alumni Hall on the Knox College campus, three pieces of Lombard College history are on display. The Lombard College bell, which Carl Sandburg rang, sits as the centerpiece. Both the Tompkins Science Hall and Alpha Xi Delta house cornerstones are also part of the collection. The items are located on the northwest side of Alumni Hall off East South Street. (Author's collection.)

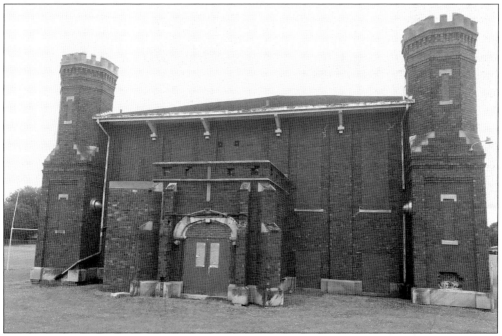

In July 2002, the sorority bungalows were demolished in favor of green space. This left the Lombard gymnasium as the only remaining on-campus structure once affiliated with the college. During both the junior high and middle school's ownership of the building, the gym became affectionately known as the Zephyr Dome, reflecting the zephyr train mascot the school had adopted. By this point, the gym had been abandoned for decades, with its windows bricked up and bats living inside. As with many of the other Lombard structures over the years, a debate raged regarding the preservation or demolition of the building. In the end, the cost of repair was too high. These photographs of the gymnasium were taken in the weeks prior to its demolition in July 2019. (Both, author's collection.)

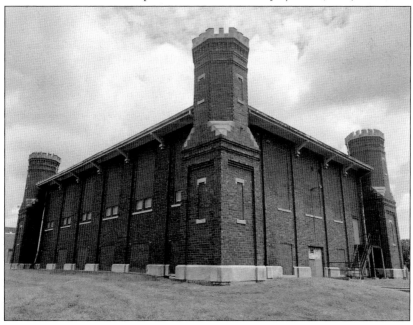

On the southeastern portion of Lombard Middle School's campus, a faint remnant of Lombard Field can still be found. A cement curb was installed in 1928 on the Lombard College track to help maintain a more perfect oval shape. Barely sticking out from the grass, the curb is the last vestige of what was once Lombard Field. (Author's collection.)

One of the more notable tributes is directly outside the doors of Lombard Middle School. The name Lombard is proudly displayed, noting the school's roots that date back to 1851. It is remarkable that Benjamin Lombard's donations to fund a college led to continuous education on this site for over 170 years. (Author's collection.)

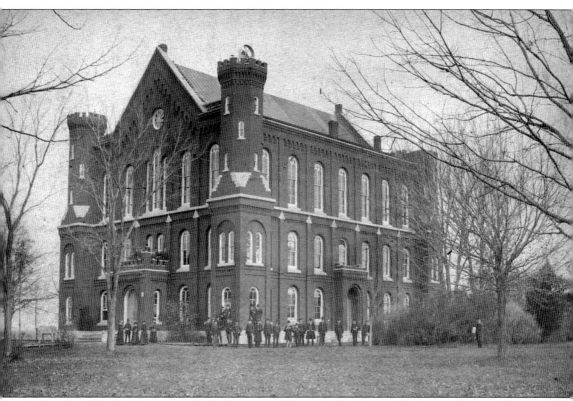

As Lombard College's campus slowly disappeared from the landscape, the alumni did too. Ray Truedson, the last living Lombard College alumnus, passed away on November 10, 2014. Even though there are no more living alumni to keep Lombard's memory alive, the college lives on through photographs, landmarks, and the generations impacted by its legacy. The spirit of Lombard College is encapsulated in the "Lombard Song," written by Benjamin Stacey. The words paint a tribute to the lasting loyalty and memory of Lombard College: "Let us always sing her praises with a voice that's loud and strong, filling all the air around us with the melody of song; let us give to her the homage, which is due from you and me, and hold sacred our memory, Lombard University." (Special Collections and Archives, Knox College Library.)

Discover Thousands of Local History Books
Featuring Millions of Vintage Images

Arcadia Publishing, the leading local history publisher in the United States, is committed to making history accessible and meaningful through publishing books that celebrate and preserve the heritage of America's people and places.

Find more books like this at
www.arcadiapublishing.com

Search for your hometown history, your old stomping grounds, and even your favorite sports team.

Consistent with our mission to preserve history on a local level, this book was printed in South Carolina on American-made paper and manufactured entirely in the United States. Products carrying the accredited Forest Stewardship Council (FSC) label are printed on 100 percent FSC-certified paper.

MADE IN THE

USA